THE MIDLAND & SOUTH WESTERN JUNCTION RAILWAY

THROUGH TIME

Steph Gillett

AMBERLEY

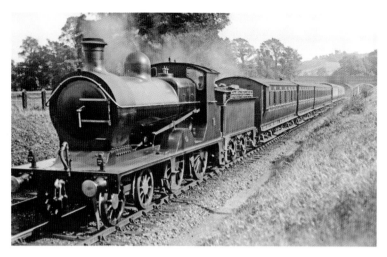

Midland & South Western Junction Railway 4-4-0 No. 7 (later GWR No. 1125), built in 1911, heads the 10.24 a.m. Southampton to Cheltenham, with through carriages for Liverpool. The train is near Charlton Kings, south-east of Cheltenham, on 17 September 1923. (Humphrey Household via David Viner)

For my sister and brother, for tolerating my enthusiasm for railways.

Front cover above: The 2.40 p.m. Andover Junction to Cheltenham train passes Charlton Kings in July 1924, hauled by Great Western Railway Duke Class 4-4-0 locomotive No. 3273 *Mounts Bay*. (Humphrey Household via David Viner)

Front cover below: Ex-Southern Railway N Class 2-6-0 locomotive No. 31816 with a southbound passenger train at Swindon Town station. (C. J. Gammell/Colour-Rail.com)

Back cover above: Contractors' Ruston & Hornsby 88DS diesel shunter removing track at City Bank, just north of Cirencester Watermoor station, in May 1963. (David Viner)

Back cover below: Looking north from the Swindon & Cricklade Railway's Blunsdon station in November 2017. (Author)

First published 2018

Amberley Publishing
The Hill, Stroud, Gloucestershire, GL5 4EP
www.amberley-books.com

Copyright © Steph Gillett, 2018

The right of Steph Gillett to be identified as the Author of this work has been asserted in accordance with the Copyrights, Designs and Patents Act 1988.

ISBN 978 1 4456 6336 4 (print)
ISBN 978 1 4456 6337 1 (ebook)

British Library Cataloguing in Publication Data.
A catalogue record for this book is available from the British Library.

Typesetting by Amberley Publishing.
Printed in Great Britain.

Foreword

It seems to be a feature of central southern England that attempts to develop railway routes running from north to south have met with some considerable resistance, both topographical and commercial. Even now it is often easier to travel along the lines of latitude than of longitude. The hills of Somerset, Gloucestershire, Wiltshire and Berkshire have played their part in resisting the early development of the warp of railway fabric and, themselves tending to be less-well populated, so were potentially less rewarding to promoters and potential shareholders.

The Midland & South Western Junction Railway (M&SWJR) was one such north–south line but had long closed when I found myself employed in Swindon in the mid-1970s and I never travelled on any part of the line prior to this. However, there was some remaining evidence around the town of 'Swindon's other railway', as it has been called. The Swindon & Cricklade Railway Society formed while I was still in Wiltshire and I became an early and active member of this embryonic group. Alongside helping with various fundraising and publicity endeavours, I joined others in recovering platform edging from the site of the Old Town station. But it was not until 2004 that I finally got to travel on part of the line, courtesy of the Swindon & Cricklade Railway, having returned to the area once more. Living then in the Chiseldon area, I also explored on foot some of the route from there.

In this short book I have tried to trace the history of the M&SWJR and highlight major milestones in its development, demise and partial resurrection. The images that follow illustrate some of the many ways in which the railway changed and developed over time, tracing the route from north to south.

Steph Gillett
Bristol
April 2018

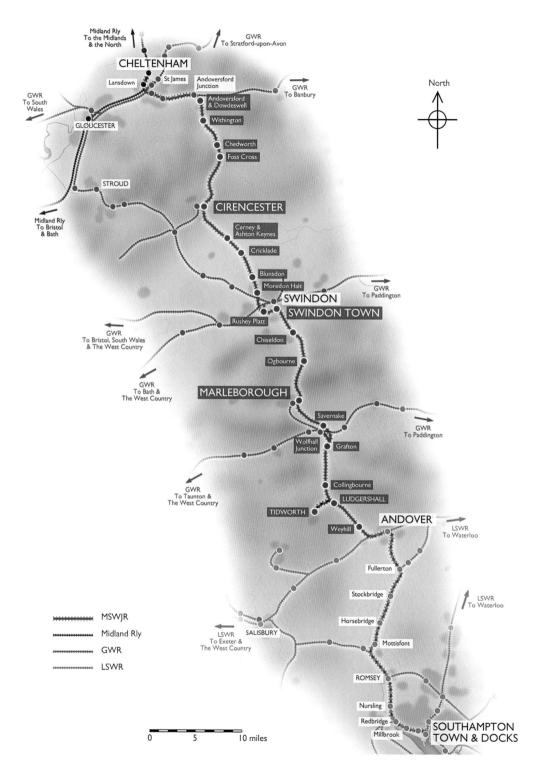

(Jon Dixon, ADA)

The M&SWJR

Origins

The Midland & South Western Junction Railway (M&SWJR) was a cross-country route. As eventually built, its network relied on the warp and weft of several other lines and passed through the 'territory' of the Great Western Railway (GWR), whose broad gauge line from London to Bristol (completed in 1841) ran through Swindon. With a station at Cheltenham, the Birmingham & Gloucester Railway, later purchased by the Midland Railway (MR), opened at the end of 1840. The Manchester & Southampton Railway was proposed to run south from Cheltenham (Midland) and would have followed a route similar to the eventual M&SWJR, but was finally rejected by Parliament in 1848.

Following authorisation of the Berks & Hants Extension Railway from Hungerford to Devizes in 1859, the people of Marlborough pressed for a broad gauge branch from Savernake. With the Berks & Hants having already suggested such a line, and the GWR promising to work it, the Act passed easily on 22 July 1861. The Berks & Hants Extension opened in November 1862 and construction of the Marlborough Railway began the following January. The branch to Marlborough opened on 14 April 1864.

The opening of the single track Andover & Redbridge line on 6 March 1865, which was doubled and realigned in 1885, provided a vital link to the south. Power to convert the Andover & Redbridge Canal into a railway had been granted in 1858 and in 1863 further authorisation was given for the line to join the Eastleigh to Salisbury branch at Romsey and be extended from Andover Town station to Andover Junction on the Basingstoke to Salisbury line.

In 1864, London engineer John Sewell proposed a route using the MR from the north to Gloucester, the GWR line to Swindon and a new railway from there to the Marlborough Railway. The promoters of Sewell's route secured Royal Assent on 21 July 1873 for two standard gauge railways: one from east of the GWR station at Swindon (passing through a 773 yard/706 metre tunnel under Swindon Old Town) to Marlborough; and another from the Berks & Hants at Savernake to west of Andover on the L&SWR line. These new lines, together with running powers over the Marlborough and Berks & Hants lines, would form the Swindon, Marlborough & Andover Railway (SM&AR). Sewell's subsequent proposals for a further line to the Solent were finally abandoned by the M&SWJR in 1893. C. L. Brooke was appointed as the SM&AR's secretary. Both the Marlborough and Berks & Hants railways were converted from broad gauge to standard gauge in the summer of 1874.

A tender for constructing the SM&AR was accepted from William Wright in 1875, but little progress was made, and all work had stopped by December as Wright did not have the funds he claimed and failed to pay his sub-contractor. The SM&AR directors cancelled their contract with him in August 1876 but struggled to find a contractor with sufficient finances to take the work on. The company carried out some works itself under its resident engineer, James Rew Shopland (1841–1897), until funds ran out and work stopped completely in October 1876. Unable to secure adequate funding, the directors proposed a new route to reduce costs, authorised on 3 July 1879, which removed the need for the tunnel at Swindon and a viaduct at Marlborough.

After several attempts to engage a new contractor, Messrs Watson, Smith & Watson were appointed in August 1879. Three outside-cylinder 0-6-0 tank locomotives (Nos 1 to 3) were ordered from Dübs & Co., Glasgow, to work the 11¼ mile (18.1 km) line from Swindon Town to Marlborough, which opened on 26 July 1881. Regular services of six trains daily each way (two on Sundays) began the following day. However, with no links to other lines, opportunities to develop freight traffic were limited.

New carriages were acquired from Metropolitan Carriage & Wagon and an articulated 0-4-4 tank locomotive was lent by Robert Fairlie in September 1881. The outside-cylinder locomotive (No. 4) was subsequently purchased in March 1882 but later found to be rather troublesome to operate and was scrapped in 1892.

The directors realised that a link to the north was vital to secure adequate traffic and promoted the Swindon & Cheltenham Extension Railway (S&CER), which was incorporated on 18 July 1881. Brooke was appointed as company secretary, duplicating his role with the SM&AR. The Act had provision for a branch from Cirencester to Fairford, but this and later proposals to link with the GWR at Cirencester or extend to Nailsworth were eventually abandoned. The SM&AR contractors were engaged to build the northern extension in October 1881. The 27¾ mile (44.7 km) line from Swindon to Andoversford was to join the Banbury & Cheltenham Direct Railway line at Andoversford with powers to run to Lansdown Junction, and on the MR line into Cheltenham (Midland) station. The Banbury & Cheltenham opened from Bourton to Lansdown Junction on 1 June 1881 and was first operated and then purchased by the GWR.

The junction at Swindon was ready in October 1881 but remained unused, due to a dispute with the GWR, until February 1882. Six trains a day ran through to Marlborough from Swindon Junction and the GWR made sure it extracted the maximum in charges that it could from the arrangement.

The Marlborough to Wolfhall Junction on the Berks & Hants section (which was purchased by the GWR in 1882) was inspected in March 1882 but not passed by the inspector, who required improvements at the junction and to the facilities at Savernake station. It was not until the end of January 1883 that arrangements for the use of Savernake station and the GWR lines were settled. Regular services on the SM&AR began on 5 February and all passenger trains conveyed through carriages for Southampton.

Pending completion of the required improvements, the SM&AR began a local service on its southern section between Andover and Grafton on 1 May 1882. A temporary junction was made with the L&SWR west of Andover, which served until November 1882, when the SM&AR's separate line between Red Post and Andover came into use. To cope with the passenger service to Andover, three inside-cylinder 2-4-0 tank engines (Nos 5 to 7) were bought from Beyer Peacock & Co., Manchester.

The Midland & South Western Junction Railway

The junction between the SM&AR and S&CER was passed in October 1883 and goods traffic between Rushey Platt and Cirencester began from November, but full opening was delayed until December by repairs to an embankment near the Wootton Bassett road. The S&CER and the SM&AR had effectively been run as one railway from the beginning,

and on 23 June 1884 the two companies merged as the Midland & South Western Junction Railway (M&SWJR).

But 1884 brought problems for the newly created M&SWJR, as both Beyer Peacock and Metropolitan Carriage & Wagon were pressing for payment. The railway later negotiated with Metropolitan to avoid them returning unpaid-for rolling stock. Only one of three more 2-4-0 tank locomotives (No. 8) ordered from Beyer Peacock could be delivered due to insufficient funds. There was no money to continue the S&CER, and the passenger service from Swindon to Cirencester was reduced to two trains daily. Watson, Smith & Watson were released from their contract and subsequently went bankrupt. In November the railway stated that it could not pay its debts, and on 20 December 1884 the company's chairman, Francis Douglas Grey, was appointed Receiver.

To avoid the charges made by the GWR, the passenger service to Swindon Junction was withdrawn in February 1885. Also in February, the general manager, Benjamin Lister Fearnley, stated that he did not believe the railway would ever be profitable; his duties were then taken over by the company secretary, Brooke. Other staff changes during 1885 and 1886 saw Shopland promoted to locomotive and carriage superintendent and A. F. R. Daniel replacing Brooke as secretary. J. F. R. Daniel (brother of A. F. R.) was appointed as general manager.

To avoid delays at Marlborough, plans for a separate line from Marlborough to Wolfhall were deposited during 1888, but were opposed by the GWR since it would have lost tolls from the M&SWJR. The proposals were dropped when the Marlborough Railway agreed to double its line, if or when the M&SWJR doubled its own from Swindon.

Charles Braddock of Wigan was appointed in April 1888 to construct the line north from Cirencester, promising completion in 1890. But while work was still in progress a section of the 494 yard (452 metre) long Chedworth tunnel collapsed in April 1890 and repairs were delayed as liability was disputed. The GWR had still not allowed the connection at Andoversford, and further problems occurred in February 1891 following failure of an embankment north of Chedworth, which destroyed a bridge. After repairs the inspector passed the line, which opened on 16 March 1891 for three goods trains each way daily.

An agreement was finally signed with the GWR on 16 May 1891 for working over the Banbury & Cheltenham, but passenger working was further delayed until improvements had been made at Cheltenham (Midland) station. The first passenger train to use the new section was an excursion from Marlborough to Birmingham on 30 June 1891. Regular passenger services began on 1 August, at last providing the long-desired link from the North to the South Coast.

Freight, including coal from South Wales and the Forest of Dean, had already been carried via the GWR and Rushey Platt to the L&SWR. With the extension to Cheltenham, goods from the north and Bristol could reach towns along the M&SWJR via the MR connection, including beer from Burton-on-Trent for export through Southampton. Northbound traffic included seasonal fruit and vegetables from Europe and the Channel Islands. In July 1891 the M&SWJR stopped running goods trains to Swindon Transfer, east of the GWR station, and traffic was then exchanged at Rushey Platt, saving running costs.

The company sought advice on managing its affairs and a meeting in February 1891 with Sam Fay (1856–1953), then of the L&SWR, led to him making proposals for improvements and offering to implement them. This was not taken up at the time, but a year later Fay was seconded as general manager for five years. The role of company secretary was combined with the post and all the railway's senior staff were dismissed, apart from Shopland, whose role changed to consulting engineer.

Through running powers from Andover Junction over the L&SWR were granted under the SM&AR Act of 1882, but were not implemented until a decade later, when a daily goods train hauled by a M&SWJR locomotive ran to Southampton Docks from November 1892.

A new fast passenger service was started between Cheltenham and Southampton on weekday afternoons in July 1893. The southbound (Down) train conveyed a MR carriage from York and the northbound (Up) one for Sheffield. Although the L&SWR provided locomotives south of Andoversford, the service still over-stretched M&SWJR resources, so the expresses ceased in October 1893.

The M&SWJR needed additional motive power to take full advantage of running powers to Southampton but lacked funds. Recently appointed company director Percy Mortimer was persuaded to provide a loan to buy a new locomotive from Dübs. The inside-cylinder 4-4-0 tender engine (No. 9) was delivered in 1893.

Fay replaced Grey as Receiver in April 1893 and secured approval from Chancery to set up a rolling stock fund in 1894. The M&SWJR was then able to buy two inside-cylinder 0-6-0 tank locomotives from Dübs. M&SWJR Nos 4 and 13 were delivered by June 1894 and first stationed at Swindon Town for goods traffic. Also supplied by Dübs were three 2-4-0 tender locomotives (Nos 10 to 12), which were delivered in May 1894. Some of the stock fund was used to build a locomotive repair shop at Cirencester; a small workshop was established by the end of 1895 and the works were fully operational within the next twelve months.

In June 1894 the through North and South Expresses were reinstated, with 4-4-0 No. 9 and the three new 2-4-0s hauling one train a day to Southampton. The MR provided through coaches to and from Sheffield and by the mid-1890s through coaches to Southampton were also carried variously from Bradford, Leeds, Derby, Liverpool, Manchester and Birmingham. Trains also ran from the north to meet ocean liners at Southampton Docks; these boat expresses continued until 1914.

The M&SWJR ordered an outside-cylinder 2-6-0 tender locomotive (No. 14) from Beyer Peacock to assist with the running of goods trains onto the L&SWR, which was delivered in May 1895. Another locomotive from Beyer Peacock arrived in July 1895, the inside-cylinder 0-4-4 tank locomotive No. 15, which worked trains from Swindon to Cirencester and Marlborough.

The Marlborough & Grafton Railway

Continuing delays to M&SWJR trains on the single line between Marlborough and Savernake led to promotion of the nominally independent Marlborough & Grafton Railway (M&GR); still in Receivership, the M&SWJR could itself not raise capital. The M&GR was incorporated on 7 August 1896, despite opposition from the GWR (which had the month before absorbed the Marlborough Railway), with Fay as secretary and Shopland as engineer. Just a week later a tender for constructing the line was accepted

from Lucas & Aird. Work began on the construction of the 6¾ mile (10.9 km) double track line soon afterwards and the first shaft for the 647 yard (592 m) long tunnel south of Marlborough was started in October 1896. Following the death of Shopland in April 1897, Richard St George Moore was appointed to supervise construction of the line.

In November 1897 the M&SWJR was finally taken out of Chancery, Fay was discharged from his duties as Receiver and settlement was made with creditors.

A second 2-6-0 locomotive from Beyer Peacock (No. 16) was delivered in May 1897. Two inside-cylinder 4-4-4 tank locomotives (Nos 17 and 18) were ordered from Sharp Stewart & Co., Glasgow. Arriving in July 1897, they were mostly used on lightweight passenger trains, being prone to wheel-slip.

The M&GR line from Marlborough to Wolfhall was completed within two years and services began on 26 June 1898. The connection with the GWR at Marlborough was severed and the original junction at Wolfhall was reduced to a wagon transfer siding. However, Wolfhall Junction was reinstated as a through line in 1902, principally for military traffic. By August 1898 through passenger trains between Cheltenham and Andover had increased to six Down and five Up trains on weekdays, with an additional train in each direction on Saturdays. There were two through northbound trains on Sundays but no Down trains. The M&GR was absorbed on 1 August 1899, formalising the M&SWJR as a coherent line from Andoversford to Andover.

The proposed Andoversford & Stratford-upon-Avon Railway would have provided the M&SWJR with an alternative route to the congested single Banbury to Cheltenham line, but this was opposed by the GWR and the Bill was defeated in 1898. The M&SWJR then sought another route north from Andoversford to the MR main line at Ashchurch.

In March 1899 Fay secured agreement from the GWR that it would double the line between Andoversford Junction and Lansdown Junction within eighteen months, if the proposed Ashchurch line was dropped and the M&SWJR would double its line south to Cirencester. The M&SWJR was also permitted to take traffic at stations between Cheltenham and Andoversford. A subsequent agreement in April 1899 gave the MR running powers over the M&SWJR and GWR from Lansdown to Andoversford. In return, the MR agreed to promote traffic over the M&SWJR.

Fay left the M&SWJR on 15 April 1899 and returned to the L&SWR as superintendent of the line, having greatly improved the situation of the M&SWJR. He later became general manager of the Great Central Railway from 1902 until 1922 and was knighted in 1912. On Fay's recommendation, James Purkess, who had started his career as a junior clerk with the L&SWR, was appointed as general manager. E. T. Lawrence became secretary, once again a separate position.

With the development of freight between the MR and Southampton Docks, yet more motive power was required. In August 1899 the first of six inside-cylinder 0-6-0 tender locomotives was delivered. The Beyer Peacock-built engines were intended for working through goods trains but were also used on passenger services. A total of ten similar engines (Nos 19 to 28) were purchased by 1902.

Eben Connal was appointed resident engineer during 1899 to oversee doubling of the line, which began in 1900. This was funded by loans from the MR but was limited to each

9

end of the railway. The section from Andoversford to Cirencester was completed by June 1902 and with widening of the GWR line, which was completed in September 1902, there were 21 miles (33.8 km) of double track from Cheltenham to Cirencester. The southern end of the line was completed to Grafton in November 1902, which, with the new line to Marlborough, gave a double track stretch of 17¾ miles (28.6 km).

The War Office requirement for a siding from Ludgershall to take building materials to the barracks at Tidworth was an important development for the M&SWJR, as Purkess persuaded them that a proper railway would be more useful. Construction began in July 1900 and the line was in use for military purposes by July 1901. The Tidworth branch was worked by the M&SWJR and operated as part of its system, with public goods carried from June and public passenger trains from October 1902.

The railway's manager, Purkess, died suddenly from food poisoning in November 1902. He was replaced by John Davies, who came from the MR. 1903 saw further changes in key personnel, with Connal being officially appointed as engineer in January, while James Tyrell (c. 1844–1948) was made the railway's first locomotive and carriage superintendent. All three held their posts until the Grouping in 1923. Later, in 1908, Lawrence was replaced by S. H. Webber as secretary, which lasted until 1917, when the role was again absorbed into the general manager's duties.

During 1904, Tyrell prepared plans for an inside-cylinder 4-4-0 tender locomotive that could take advantage of the improved permanent way. Intended to work fast passenger traffic, its 5 foot 9 inch (1.75 m) diameter driving wheels were small enough to deal with other traffic and the line's gradients. Built by the North British Railway Co., Glasgow, the first engine (No. 1) was delivered in July 1905. The new engine was successful, and it was decided to buy a second if some of the older smaller engines could be sold. Two 0-6-0 tank locomotives (Nos 2 and 3) and one 2-4-0 tank engine (No. 6) were eventually sold in 1906. However, the price had gone up and the company waited until 1909, when the cost had fallen again, to purchase replacements. A further eight engines in the class were purchased from North British between 1909 and 1914 (Nos 2 to 8 and 31).

A new connection with the GWR at Wolfhall was created in September 1905. The curved double track loop line ran from Grafton East Junction on the Berks & Hants line to Wolfhall Junction on the M&SWJR. Grafton East Curve was used for occasional military traffic and excursions.

In the years before the First World War through passenger services were improved and accelerated, with two South Expresses to Southampton, one from Birmingham and another from Manchester (London Road), but the start of hostilities in 1914 led to a dramatic increase in military traffic. Passing loops and sidings were lengthened to cope with the thousands of troop and ambulance trains. By the end of the war in 1918 the railway was in a run-down state and needed the support of the MR to recuperate. With a recession, and continuing restrictions on non-essential travel, the M&SWJR was forced to cut services.

The Great Western Railway

The Railways Act of 1921, intended to remove the inefficiencies of pre-war competition, passed the M&SWJR to the GWR under the Grouping. But absorption was delayed until

agreement had been reached on the outstanding loans from the MR, and the GWR did not take legal control until October 1923. In anticipation of this the GWR started working goods trains through to Swindon Town in January 1922. Twenty-nine locomotives were taken into the GWR together with 134 carriages, 260 goods and 119 service vehicles. At the Grouping the M&SWJR had 60.7 route miles (97.7 km), worked the 2.4 miles (3.9 km) of the Tidworth branch and had 37.3 miles (59.9 km) of running powers over the L&SWR, GWR and MR.

There were many changes following the takeover by the former competitor company, but the GWR shelved some of its early plans, which included providing a connection between its line to Gloucester and the M&SWJR between Swindon and Purton. GWR rolling stock and locomotives were increasingly used alongside ex-M&SWJR classes, including tank engines on ex-works 'running-in' turns on the reinstated Swindon shuttle service.

As well as receiving new numbers and liveries, many of the ex-M&SWJR locomotives were provided with replacement boilers and other Swindon fittings during works visits. Not all the rebuilt engines remained on the M&SWJR route, however. Former No. 16 (GWR No. 24) worked goods trains to the Bristol area with a new boiler until it was withdrawn in 1930. The solitary Dübs 4-4-0 tender locomotive (No. 9) did not fare so well, being withdrawn in January 1924. The 0-6-0 tank engines Nos 13 and 14 (GWR Nos 825 and 843) remained in their pre-Grouping form and were used mainly for working the Tidworth branch until withdrawal in 1926. All three Dübs 2-4-0s, Nos 10 to 12 (GWR Nos 1334 to 1336), received new boilers to replace their condemned ones but were all transferred to the Reading area by 1925; they survived until the early 1950s and were the only M&SWJR engines to be taken into British Railways stock.

The Sharp Stewart 4-4-4 tank locomotive No. 17 (GWR No. 25) had no major modifications and it worked the Swindon shuttle until withdrawal in 1927. However, No. 18 received a taper boiler and an entirely new appearance. As GWR No. 27, this engine then worked in the Kidderminster area until condemned in 1929. Beyer Peacock 0-4-4 tank engine No. 15 (GWR No. 23) also received a new boiler; it worked the Swindon shuttle service from April 1927 until December 1929 and was then withdrawn.

All the Beyer Peacock 0-6-0 tender locomotives (GWR Nos 1003 to 1011 and 1013) also acquired taper barrel boilers and new cabs. They continued to work on the M&SWJR section until they were withdrawn between 1934 and 1938. Overhauls of the North British 4-4-0 tender engines (GWR Nos 1119 to 1126 and 1128) gave some class members taper boilers, while others retained parallel ones fitted with superheaters, some with double-domes. The class was withdrawn between 1931 and 1938.

The former M&SWJR headquarters at Swindon and the engine shed at Cirencester were closed in 1924. Locomotive repairs at Cirencester ended the following March and the works closed completely in October 1925. In November 1926 the old connection between the two lines at Marlborough was reinstated for wagon transfers but there were further economies to follow. The double track line from Andoversford Junction to Cirencester was made single in July 1928, after which the train service deteriorated. From 1930 there was a programme of bridge strengthening in order to allow the use of heavier classes of GWR locomotive. The remaining ex-M&SWJR engines were withdrawn or

transferred away by the end of the decade to be replaced by a variety of GWR tender and tank locomotive classes.

In 1933 the GWR made significant changes to the track layout between Marlborough and Wolfhall Junction (Grafton). The double track of the former M&GR line south of Marlborough was made single during February and March, with only the old Down line continuing to run to Savernake High Level (the former M&SWJR station). The Marlborough branch was diverted onto the then independent M&GR Up line at Hat Gate, where the railways were closest. The rest of the Marlborough Railway was abandoned and lifted, apart from a short length at Marlborough to reach the GWR High Level station (which was closed to passengers). Most trains then ran via Savernake Low Level and the shuttle service from Savernake was diverted to Marlborough Low Level (ex-M&SWJR).

Traffic on the railway increased as another major military conflict approached and there was a frequent service on the Tidworth branch. Through passenger services were once again stopped by the outbreak of the Second World War in September 1939. Wartime military traffic was very intense, the line providing a strategic route to the South Coast that avoided London and served military camps in Wiltshire. Trains carrying troops, armaments and supplies ran to Southampton and Portsmouth, while the inevitable ambulance trains ran in the opposite direction.

Heavier locomotives (including War Department types) were employed during the war, taking advantage of the upgraded bridges, and track capacity was again increased by extending sidings and loops. Many trains ran to Tidworth following the evacuations from Dunkirk in 1940. The line from Weyhill to Red Post Junction was doubled and an ammunition dump was created in Savernake Forest in August 1943; the sidings remained until 1950. Around seventy special military trains brought troops and supplies to the area in preparation for the Normandy landings in 1944.

The M&SWJR carried a heavy burden during the war and was, like the railway network generally, in a rundown condition by its end, despite benefitting from some wartime improvements to the infrastructure. It was also facing increasing competition for passengers, milk and freight from road transport. In 1945 there were just three through trains between Cheltenham and Andover.

British Railways

At Nationalisation of the railways on 1 January 1948, the M&SWJR line became part of the Western Region of British Railways (BR), but from April 1950 to February 1958 management and maintenance of the line was split between the Western and Southern Regions.

There was a general running down of services and facilities during the 1950s as BR sought economies throughout its network. The former M&SWJR engine shed at Andover Junction closed in 1953, as did most of the railway system within Tidworth Camp. The passenger service to Tidworth was withdrawn in September 1955 and in November all workings on the branch passed to the War Department. Grafton Curve closed in May 1957 and in June 1958 all but one through train was withdrawn and local services were cut, especially north of Swindon.

Savernake High Level station was closed in September 1958 and services were diverted to Low Level; the line from Wolfhall Junction was lifted by April 1960. Freight train withdrawals at the end of 1958 left only a local goods service south of Cirencester. Track changes at Cheltenham meant that from November 1958 any through trains ran to the former GWR St James station rather than the former MR one at Lansdown.

Further rationalisation in 1960 resulted in single line working south of Ludgershall and removal of the war-time connection at Red Post Junction. In March 1961 BR announced the withdrawal of all passenger services in September due to financial losses. The railway was in a very rundown state; a passenger in May witnessed an ailing locomotive being revived by the use of a large hammer. The last regular services north of Rushey Platt ran on Saturday 9 September 1961, with enthusiasts' specials running throughout the following day alongside the Sunday service from Swindon to Andover.

Andoversford Junction station remained open for passengers and goods until October 1962; the line to Cheltenham closed completely in September 1964. Passenger services on the Andover & Redbridge line were withdrawn in September 1964 and the line closed south of Andover Town, to where a goods service continued until 1967. Savernake Low Level was renamed 'Savernake for Marlborough' on closure of the M&SWJR line but then closed in April 1966. The Berks & Hants line remains open.

Some sections of the M&SWJR were kept open for freight traffic: Andoversford Junction to Andoversford & Dowdeswell (until October 1962); between Savernake and Marlborough (goods and coal until May and September 1964 respectively); Swindon Junction to Rushey Platt; Swindon Town to Cirencester; and from Andover Junction to Ludgershall. The military branch to Tidworth closed in July 1963 but a short section was retained to serve military facilities, including the armoured vehicle depot, which closed in 1997. The redundant track from Ludgershall to Grafton was lifted during 1963, between Marlborough and Swindon in 1964 and from Cirencester to Andoversford by the end of 1964.

Swindon Town closed to general goods in May 1964, but remained open for coal traffic until November 1966, and then for another two years as a private siding for an Esso oil depot. Towards the end of 1970 the station site was used as a railhead for roadstone for constructing the M4 motorway. The line from Rushey Platt to Moredon was used for coal trains to the power station, until this was decommissioned in 1973, though track remained until around 1980; track north of Moredon was removed in 1965.

The line to Ludgershall closed to public goods in March 1969, but continues to carry military traffic, though this has been much reduced in recent years, and several diesel and steam-hauled excursion trains have visited the branch. Local politicians submitted proposals at the end of 2017 for a reinstated passenger shuttle service from Andover along the branch.

The Swindon & Cricklade Railway (S&CR) developed from a society formed in February 1978. The volunteer-run S&CR took over Blunsdon station site in March 1979 and by 1983 had reinstated half a mile (0.8 km) of railway from the River Ray towards Hayes Knoll, running its first public steam trains in October 1984. The River Ray was re-bridged in 1993.

A restoration centre was established at Hayes Knoll in the late 1990s and by 2009 a new station was being developed near Mouldon Hill at the southern end of the line. An extension northward to South Meadow Lane was completed in 2008, and trackbed clearance recommenced in 2013 with plans in 2018 to re-lay track to Farfield Lane. The railway's third station, Taw Valley Halt, opened in 2014 pending a future extension into Mouldon Hill Country Park itself. Also in 2014, an extension to the restoration centre provided a new engine shed to house some of the railway's collection of former main line and industrial, steam and diesel locomotives.

Physical evidence of the M&SWJR can be found throughout its route, including many bridges and culverts, tunnels, embankments, and remnants of station sites. Few of its buildings survive though, and redevelopments at Andoversford, Cirencester, Swindon, Marlborough and elsewhere have all but obliterated any sign of the railway. There are pleasant walking and cycling routes along sections of the trackbed from Chiseldon to Marlborough, north from Swindon and through the Cotswold Water Park south of Cirencester.

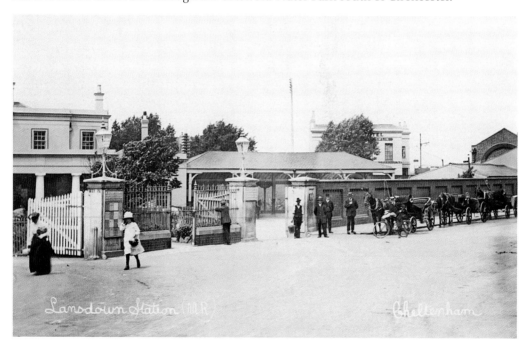

The Midland Railway's station at Cheltenham was opened in June 1840 with the Bromsgrove to Cheltenham section of the Birmingham & Gloucester Railway. This view, c. 1917, shows the station entrance on the Down (east) side of the line. It was renamed Cheltenham Spa Lansdown in 1925. (Cheltenham Local & Family History Library)

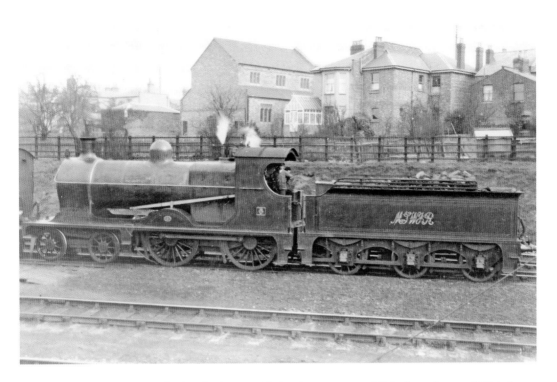

The M&SWJR engine shed and sidings at Cheltenham were established south-east of High Street station on the Cheltenham to Birmingham line. M&SWJR 4-4-0 No. 6 (later GWR No. 1124) was delivered from the North British Locomotive Co. in 1910. (Lens of Sutton via Swindon Society)

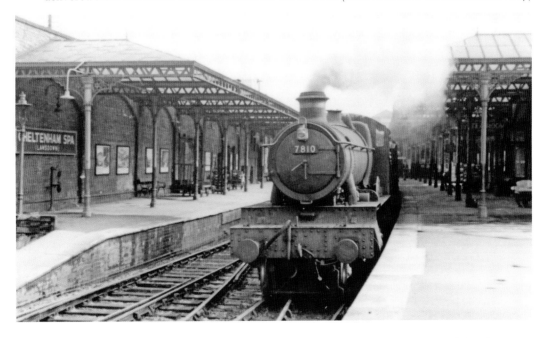

Ex-GWR No. 7810 *Draycott Manor* stands at the Down main line platform of Cheltenham Spa (Lansdown) with the 10.00 a.m. train to Southampton on 1 May 1956. At this date No. 7810 was allocated to Gloucester Horton Road shed. (H. C. Casserley)

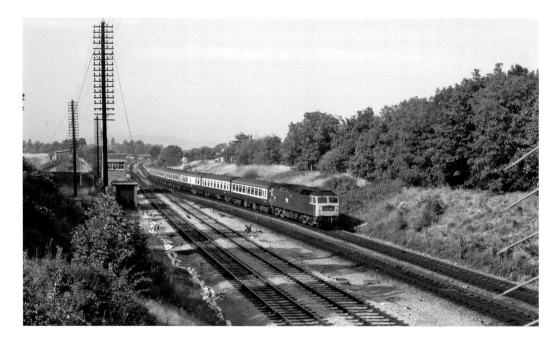

A Class 47 diesel-hauled express to Birmingham takes the line towards Cheltenham Spa station from Lansdown Junction in August 1976. Changes to the junction in 1958 caused the diversion of M&SWJR trains via the tracks in the foreground to St James station (which was closed in 1966). (Peter Russell)

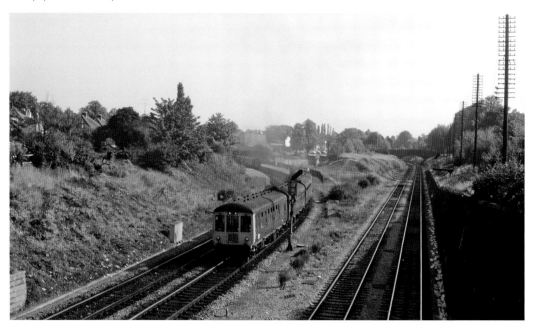

Two three-car diesel multiple units form a southbound train from Cheltenham Lansdown station (just visible beyond) on the former MR line towards Gloucester on 21 August 1976. The former GWR line from Honeybourne to the right closed in November 1976. (Peter Russell)

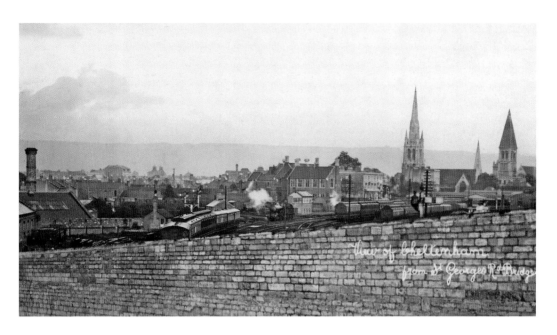

The GWR opened its station at Cheltenham in October 1847 on a spur line from Lansdown, which was replaced by larger facilities in September 1894. It was renamed Cheltenham St James in May 1908 and Cheltenham Spa (St James) from February 1925. This view from St Georges Road bridge is dated 1913. (Cheltenham Local & Family History Library)

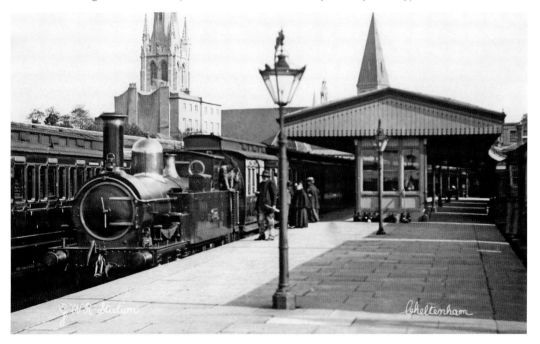

Cheltenham St James comprised two island platforms running from a large concourse, at which a GWR 2-4-0 Metro Tank locomotive stands in 1913. The station became less important with the opening of Malvern Road station on the through line to Honeybourne. (Cheltenham Local & Family History Library)

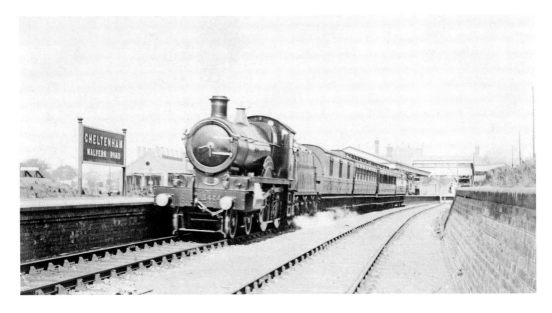

Cheltenham Malvern Road station opened on 30 March 1908 on the GWR line from Honeybourne, which had opened in August 1906. Before this, trains from Honeybourne had to reverse into St James station. GWR County Class 4-4-0 locomotive No. 3474 *County of Berks* of 1904 stands at the island platform in 1909. (Cheltenham Local & Family History Library)

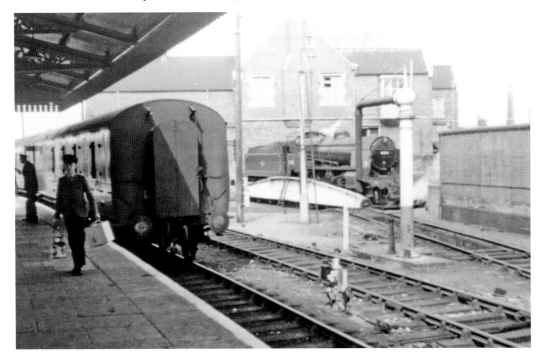

Following changes to the track layout at Lansdown in 1958, trains from the M&SWJR line were diverted to Cheltenham St James. An ex-SR mogul locomotive is on the turntable following the arrival of a train. The station closed to passengers in January 1966 and to goods ten months later. (Swindon Society collection)

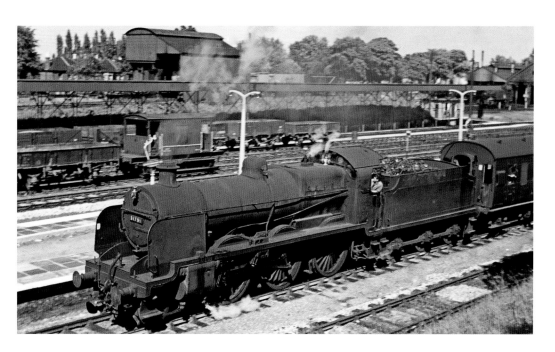

Ex-SR U Class 2-6-0 tender locomotive No. 31791 is at Cheltenham Malvern Road en route from St James in 1960. The goods yard and loco shed to the north and west of the station opened first in 1907. The engine shed closed in March 1964 and the station closed in January 1966. (B. Nottingham/Colour-Rail.com)

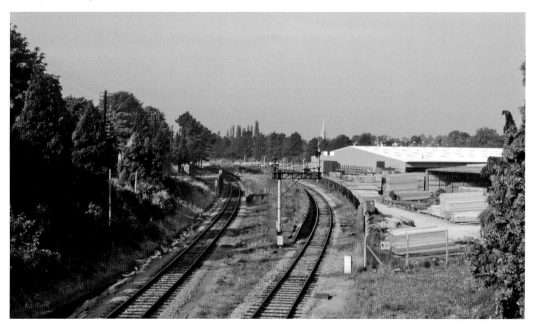

Looking south-west from the Malvern Road bridge in August 1976, two tracks are in place through the station site and the island platform remains can be discerned between them, including the short bay platform in the foreground. A timber yard occupies the site of the goods yard and engine shed. (Peter Russell)

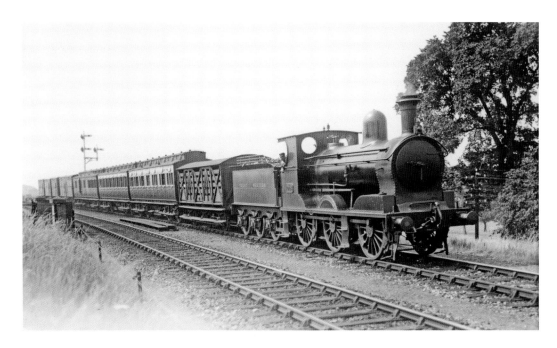

Ex-M&SWJR 0-6-0 No. 1008 (formerly No. 24 of 1899) is approaching Hatherley Junction, south Cheltenham, with the 8.00 a.m. Andover Junction to Cheltenham train on 2 July 1925. The junction provided a direct link via the Gloucester Loop south to Gloucester, avoiding Cheltenham. (Humphrey Household via David Viner)

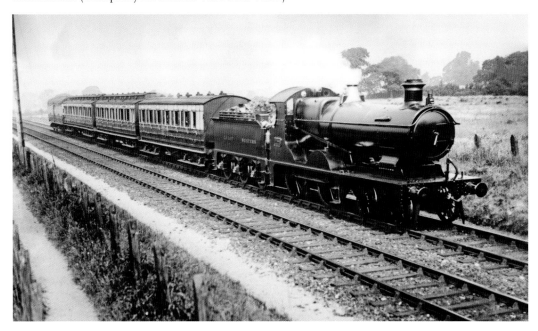

Leckhampton station opened in June 1881 and was used by M&SWJR trains from 1891. Near Leckhampton with the 10.28 a.m. Cheltenham to Andover Junction on 13 July 1925 is ex-M&SWJR NBL-built 4-4-0 No. 1128 (originally No. 31), as rebuilt with a taper boiler by the GWR in 1924. (Humphrey Household via David Viner)

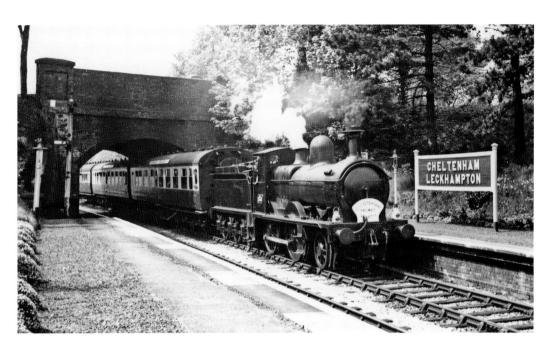

One of only three M&SWJR locomotives to survive into BR, Dübs-built 2-4-0 No. 1336 (M&SWJR No. 12) passes Cheltenham Leckhampton (as renamed in 1952) with a Gloucestershire Railway Society special on 9 May 1953. Rebuilt with GWR boilers, the three engines worked in the Reading area until withdrawn in 1952 and 1954. (STEAM Picture Library)

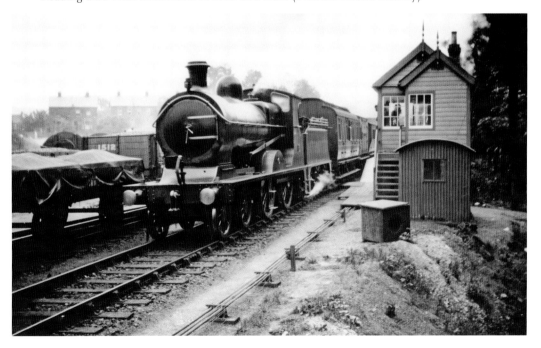

An unidentified M&SWJR 4-4-0 passes the signal box at Charlton Kings as it leaves with the 8.00 a.m. Andover Junction to Cheltenham on 8 June 1922. The signal box closed in December 1954 with the withdrawal of goods services from the station. (Humphrey Household via David Viner)

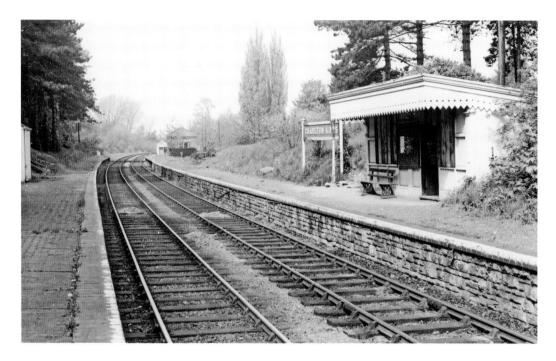

Opened in June 1881 on the Banbury & Cheltenham Railway, Charlton Kings station served M&SWJR services from 1891. The main station building was constructed of timber with a brick chimney. The platforms were accessed from the adjacent road bridge. (Swindon Society collection)

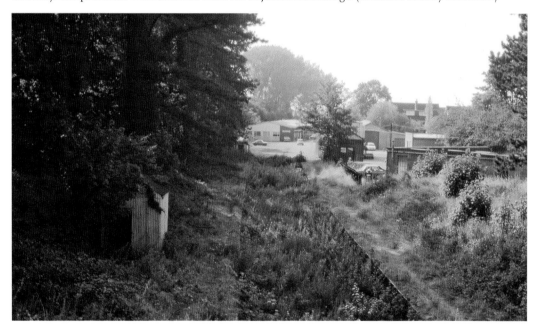

Charlton Kings station closed to passengers in October 1962, nearly eight years after losing its goods services, with the closure of the line from Bourton-on-the-Water. There is still some evidence of the station in this August 1976 view west from the bridge, but the site is now occupied by industrial development. (Peter Russell)

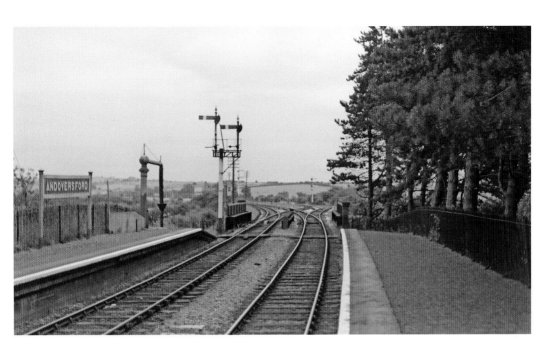

Andoversford opened with the extension of services from Bourton-on-the-Water in June 1881. It became a junction station when the S&CER was completed from Cirencester but M&SWJR trains were not permitted by the GWR to use the station until October 1904. This is the view east towards the junction in 1959. (James Harrold/Transport Treasury)

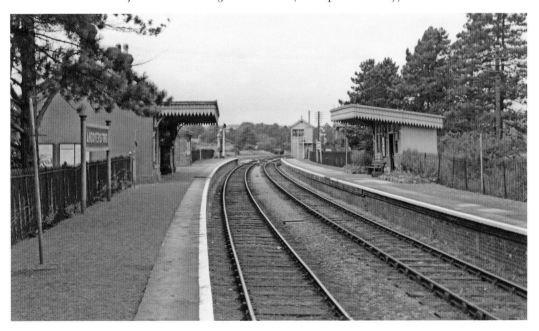

The main station building at Andoversford was located on the Cheltenham-bound platform and a wooden shelter was provided on the other platform, as seen on the right in this 1959 view, with the GWR signal box of 1925 beyond. The station was renamed Andoversford Junction in July 1926. (James Harrold/Transport Treasury)

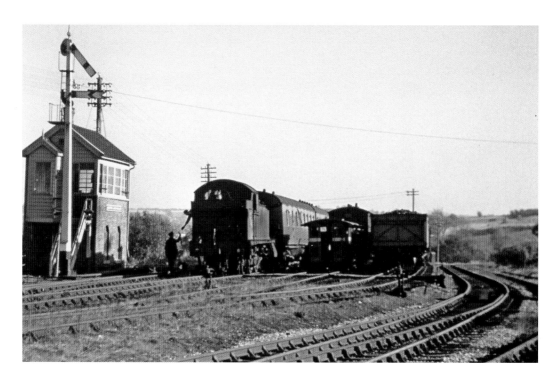

Andoversford Junction signal box, east of the junction and north of the line, was constructed by Duttons at the expense of the M&SWJR and came into use in 1891. It closed in 1962 but was kept as a ground frame until December 1964. Ex-GWR 2-6-2T No. 5514 is seen alongside in 1955. (S. Townroe/Colour-Rail.com)

Andoversford Junction station closed in October 1962 with withdrawal of the remaining passenger and goods services. The remains of the platforms are seen here in August 1976, but nothing now remains of the station site. (Peter Russell)

Dowdeswell station was opened for goods traffic in March 1891 with the completion of the line from Cirencester, but was not ready for passenger trains until August 1891. Renamed Andoversford & Dowdeswell in October 1892 and closed to passengers in April 1927, the abandoned Up platform is seen in July 1961. (James Harrold/Transport Treasury)

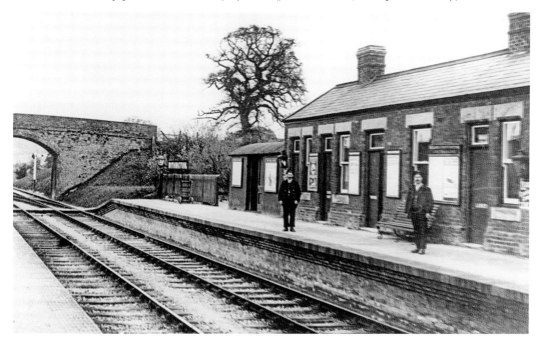

This view, looking south toward bridge No. 187, shows Withington station in 1912 with the signalman and station master posing on the Up platform in front of the station building and adjacent store. The station was downgraded to a halt in May 1956. (Swindon Society collection)

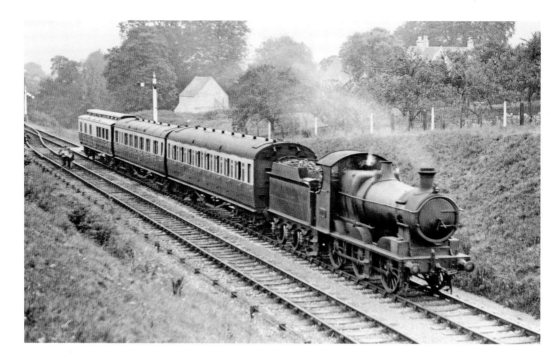

Approaching Withington station in 1935 with a train for Cheltenham is ex-M&SWJR 0-6-0 No. 1011 (formerly No. 27 of 1902), as rebuilt in 1925. In this form they were the only 0-6-0 tender engines with taper boilers in GWR stock until the introduction of the Collett 2251 Class in 1930. (Swindon Society collection)

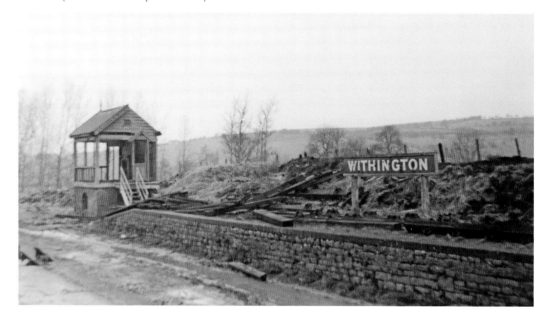

The Dutton & Co. supplied signal box at Withington was closed in 1956 with the withdrawal of goods facilities. The loop was extended for wartime goods traffic in 1942 and was retained until 1957. This post-closure view is from March 1964. The Up platform edge survives within the timber yard that now occupies the site. (David Viner)

Gloucestershire Wildlife Trust's nature reserve at Chedworth includes the former M&SWJR trackbed between White Way bridge (No. 178) and the northern portal of Chedworth Tunnel, including bridge No. 177, as seen here in November 2017. (Author)

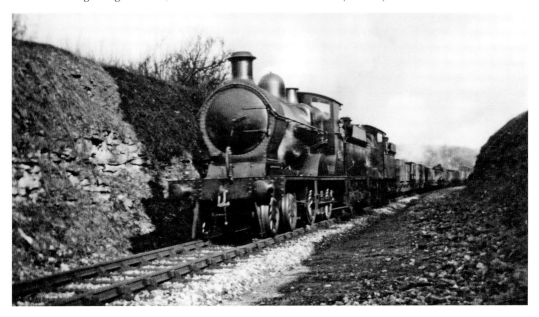

The 7.35 a.m. ex-Cheltenham goods train is double-headed by 4-4-0 No. 1125 (ex-M&SWJR No. 7) and 0-6-0 No. 1009 (ex-M&SWJR No. 25) at milepost 54.5 near Chedworth Roman Villa in 1932. (STEAM Picture Library)

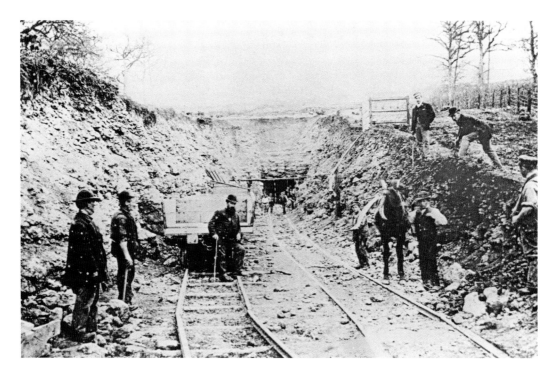

Men working for the contractor Charles Braddock are seen cutting the northern entrance to Chedworth Tunnel *c.* 1888. Braddock had 400 men working on the 495 yard (453 m) long tunnel at this date. (A. N. Irvine via Swindon Society)

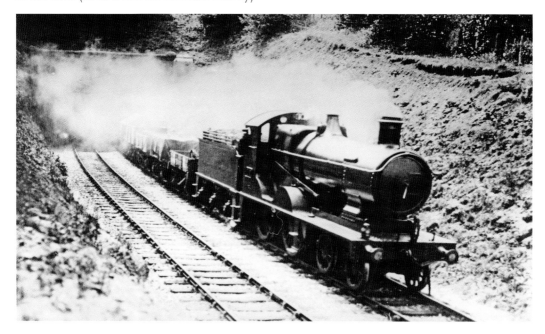

A northbound freight train exits Chedworth tunnel on 24 June 1925 behind ex-M&SWJR 4-4-0 No. 1121, as rebuilt with a taper boiler by the GWR in 1924. The engine was delivered by the North British Locomotive Co. in 1909 to become M&SWJR No. 3. (Humphrey Household via David Viner)

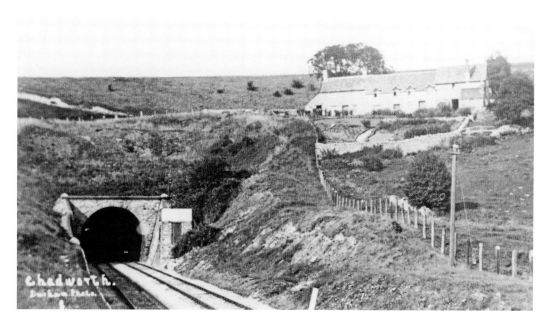

The south portal of Chedworth tunnel (bridge No. 175) is seen *c.* 1903 after the doubling of the line. The foundations of the water tower by the entrance survive in the now heavily overgrown cutting, which lies within private land. (A. N. Irvine via Swindon Society)

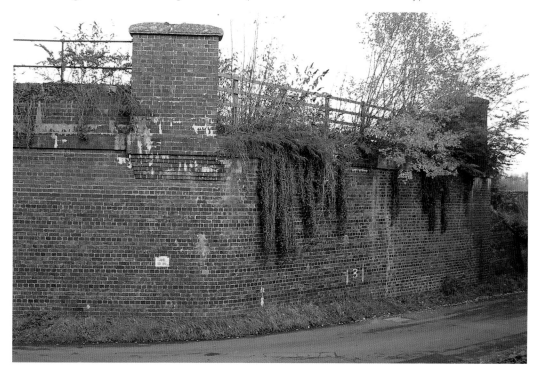

The substantial abutments of bridge No. 172 provide a sometimes colourful monument of the M&SWJR, as seen here in November 2017. The skew girder bridge originally spanned Cheap Street, north of the station at Chedworth. (Author)

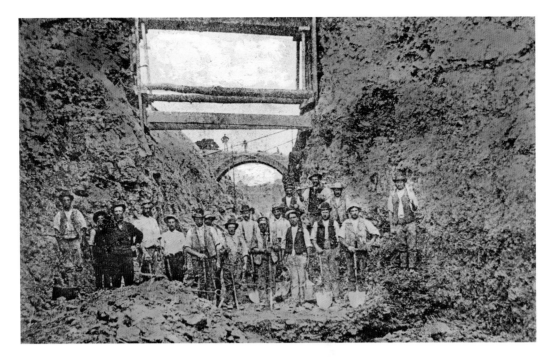

Men engaged in construction of the S&CER pose in the newly dug cutting at Chedworth, with bridge No. 171 beyond. Braddock's 1,000 navvies had only one steam excavator to assist them when they started work in 1888. (Swindon Society collection)

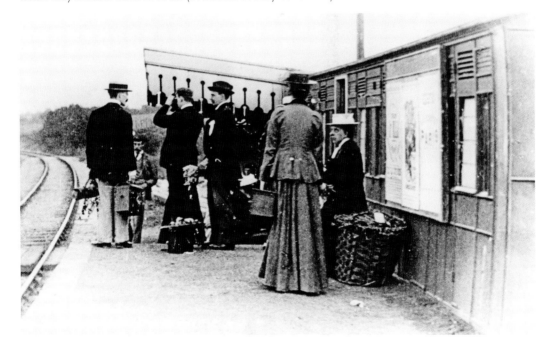

The first station at Chedworth was opened on the single-line M&SWJR on 1 October 1892, following requests from local inhabitants who objected to walking to Foss Cross station. There were limited facilities for passengers and none for goods traffic. (Swindon Society collection)

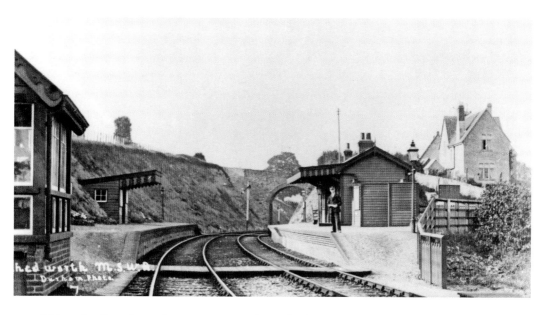

When the line from Cirencester to Andoversford was doubled in 1902, a new station was built at Chedworth, north of the original. The main station building was on the Down side; the shelter on the Up platform is believed to have been re-used from the first station. (Swindon Society collection)

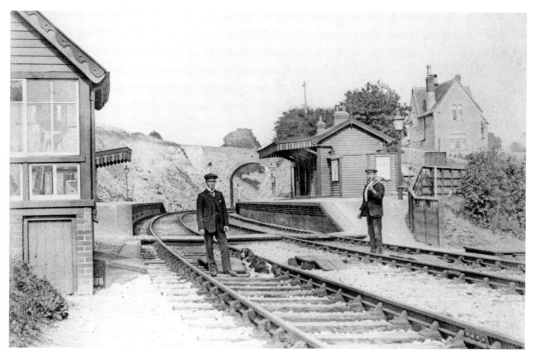

The signal box at Chedworth at the southern end of the Up platform, a Dutton type supplied by McKenzie & Holland, was in use only from doubling in 1902 to singling again in 1928. Stationmaster Fred Tucker and ganger Mr Robins pose on the foot crossing between the platforms *c*. 1905. (J. Hopper via Swindon Society)

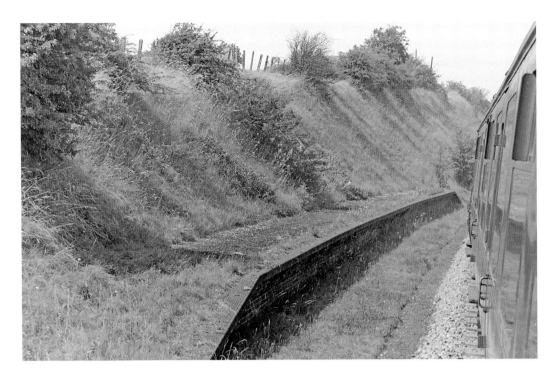

The Up platform at Chedworth, redundant after singling of the line in 1928, is seen from a train in July 1961. The station was reduced to halt status in 1925 and all staffing was withdrawn in February 1954. The cutting is now partially filled and the site is occupied by housing. (James Harrold/Transport Treasury)

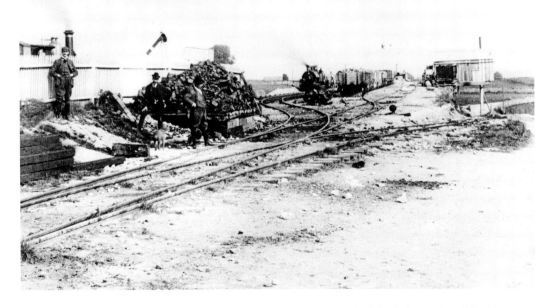

The limestone quarries north and south of Foss Cross station had both been closed by the mid-1950s. The sidings for the northern quarry are seen looking north from the goods loop behind the Down platform, c. 1902. (A. N. Irvine via Swindon Society)

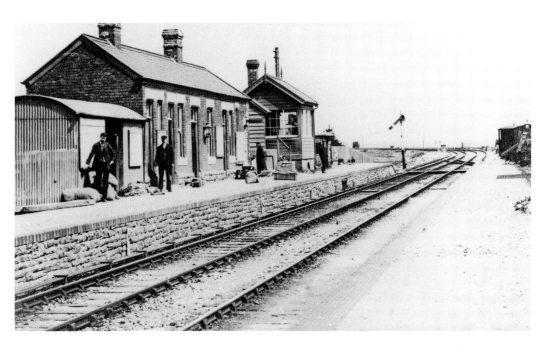

When opened in August 1891, Foss Cross station provided a crossing point on the single line between Cirencester and Withington. The station buildings on the Up platform, seen in 1907, were similar to those at Withington. The adjacent signal box controlled both the running line and the quarry sidings. (Lens of Sutton via Swindon Society)

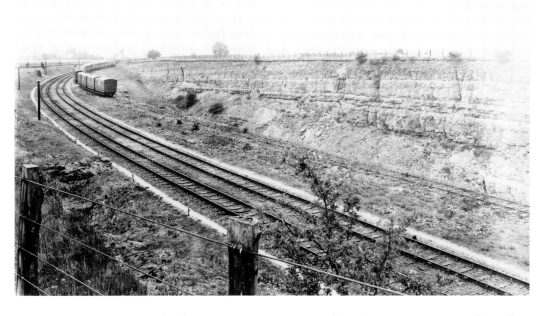

The quarry siding south of Foss Cross station was used by the GWR to store surplus rolling stock after the Grouping. The Fosse Lime & Limestone Co. took the site over in 1928 and developed substantial works, which lasted until 1955. (STEAM Picture Library)

Cirencester station opened for passengers on 18 December 1883 with the extension from Swindon and served as northern terminus of the M&SWJR until 1891. This view from 1961 shows the exterior of the station building on the west side of the line. (Leslie Reginald Freeman/ Transport Treasury)

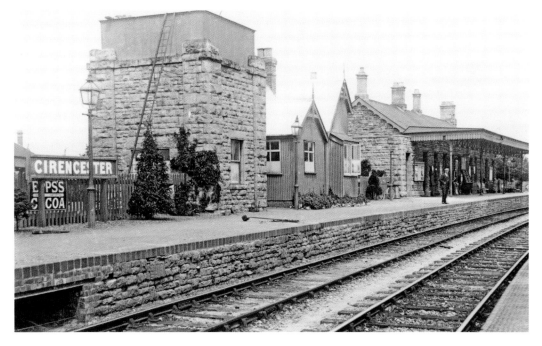

A large water tower stood on the Up platform at Cirencester, adjacent to the corrugated iron station master's house (later used as offices) that was next to the station building. A larger water tank of 15,000 gallons (68,191 litres) was later installed in 1912. (David Viner collection)

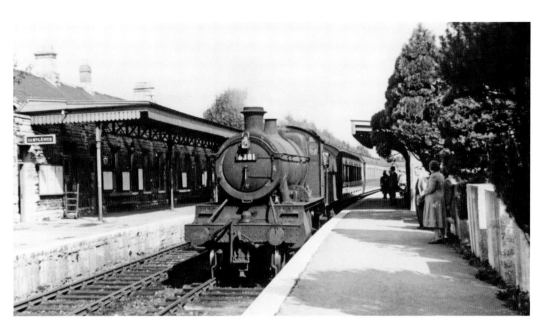

Ex-GWR 2-6-0 No. 6381 stands at Cirencester Watermoor with a southbound train in 1952. The station was renamed in July 1924 to avoid confusion with Cirencester Town, the terminus of the GWR branch line from Kemble that opened in 1841. The line north was doubled in July 1901 but was reduced to single track again in 1928. (STEAM Picture Library)

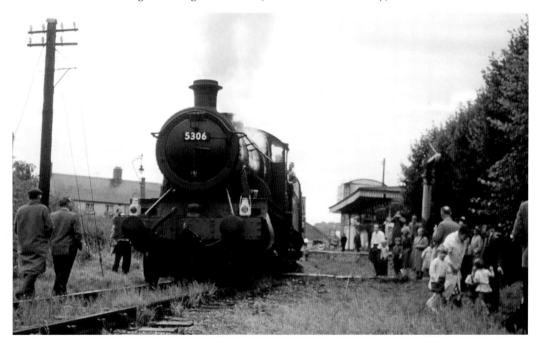

One of the two special trains marking the closure of the line that ran on 10 September 1961. Ex-GWR 2-6-0 No. 5306 with the RCTS railtour stands in the former Down platform of Cirencester Watermoor; the Up track was not used after March 1960 following damage by a vehicle to the Gas Lane under bridge (No. 152). (Colour-Rail.com)

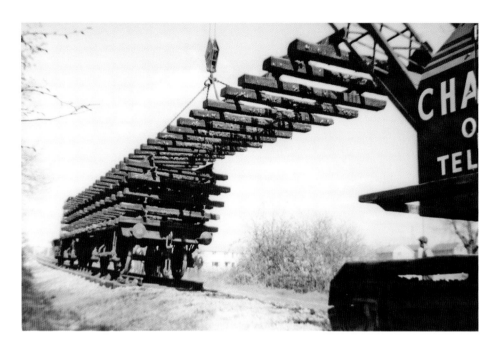

Pittrail Ltd, Staffordshire, began track removal north of Cirencester in March 1963, using stripped down four-wheel trucks to transport materials to Foss Cross for dismantling. Track panels are being loaded by mobile crane just north of Watermoor station at City Bank in May 1963. (David Viner)

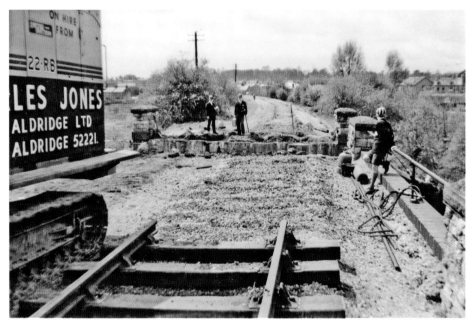

Boys from Cirencester Grammar School watch track removal operations at bridge No. 156 at Cirencester. An abutment of the bridge survives near the City Wall path. The contractors used a Ruston & Hornsby 88DS diesel shunter to assist with the dismantling work. (David Viner)

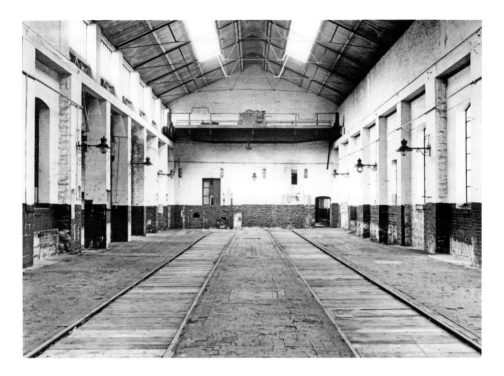

The M&SWJR's locomotive, carriage and wagon works were built at Cirencester in 1895. The facilities were expanded in phases, up to 1915 at least, but closed in 1924. The interior of the locomotive shop is seen in May 1926. (BR via Swindon Society)

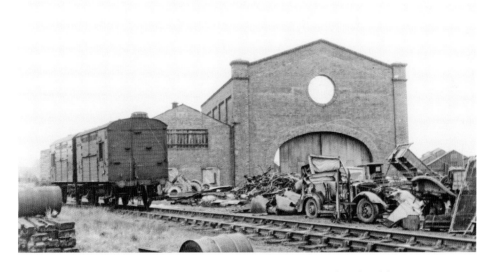

Following takeover by the GWR, the works at Cirencester were closed and locomotive repairs were carried out at their long established factory at Swindon. For some years the redundant site at Cirencester was used by a scrap metal dealer, as seen here in May 1956, with two horseboxes in the siding. (H. C. Casserley via Swindon Society)

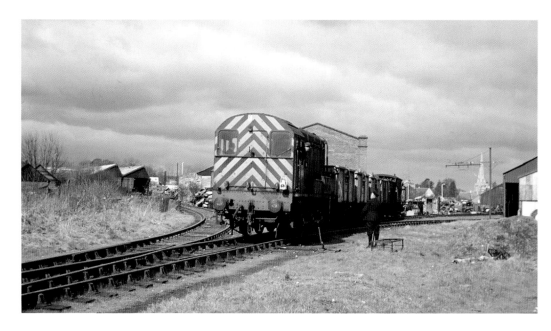

Diesel-hauled freight services between Swindon and Cirencester continued until March 1964. Class 08 diesel shunter D4020 moves mineral wagons in the goods yard, adjacent to the former works buildings at Cirencester, on 25 March 1964. (Colour-Rail.com)

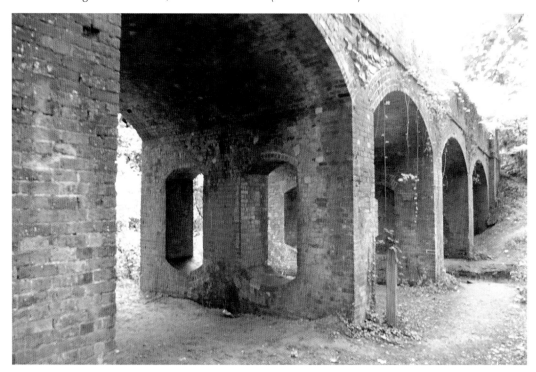

One of four multiple-arched brick overline bridges in the South Cerney area, this is No. 134 at Chapter House, north of the station, in September 2017. The others are on a public right of way along the trackbed in the Cotswold Water Park. (Author)

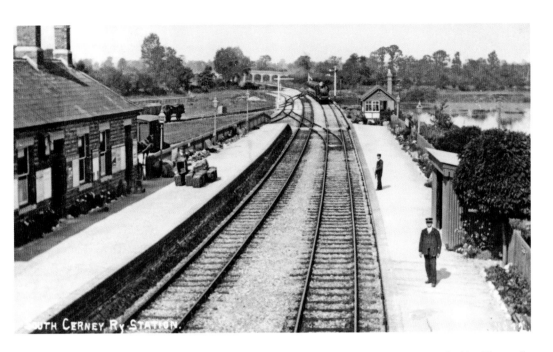

A view looking north from the road bridge (No. 130) at Cerney station around 1907. The main station building was on the Up platform, left, and the signal box at the far end of the Down platform dates from 1900, when the crossing loop was brought into use. (Lens of Sutton via Swindon Society)

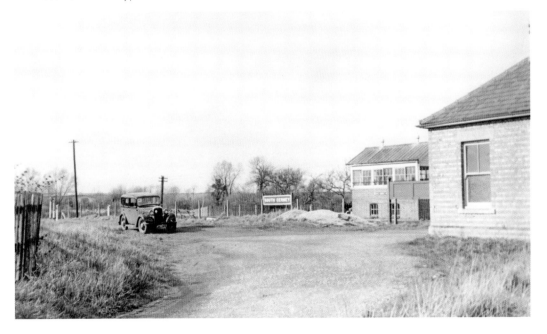

A view of the signal box and the end of the station building (extreme right) at South Cerney from the station approach in April 1958. The GWR signal box was installed when the passing loop was extended. The photographer's 1934 Hillman Minx saloon stands in what was the goods yard. (H. C. Casserley via Swindon Society)

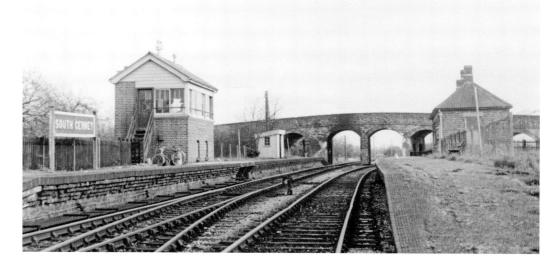

South Cerney station (renamed from Cerney in 1924), seen from the north in 1958. The multiple-arch road bridge (No. 130) survives, though the station site has been taken over by residential development. The standard GWR signal box on the Down side replaced the previous Dutton type in 1942. (H. C. Casserley via Swindon Society)

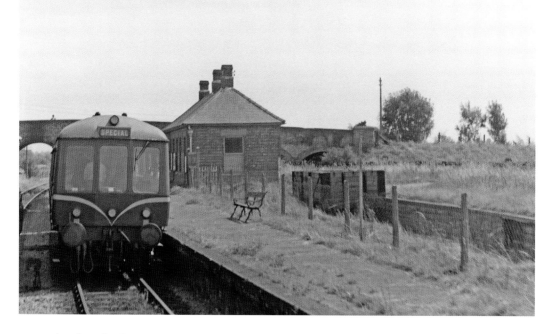

A BR diesel multiple unit (DMU) heads north at South Cerney and is seen from a passing Down train on 26 July 1961. DMUs were run after construction at Swindon Works for trials and driver familiarisation just before closure, but were not used on revenue-earning services. (James Harrold/Transport Treasury)

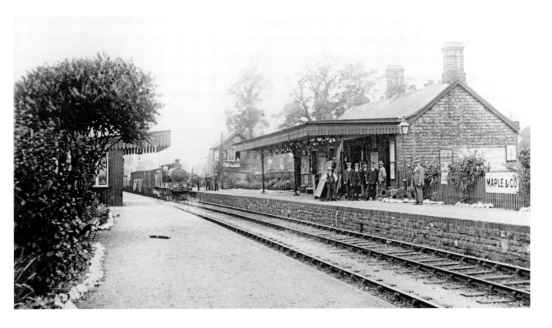

A view of Cricklade station sometime during the ten years to 1912, with a Down goods train approaching behind a Beyer Peacock 0-6-0 tender engine. The advertisement on the right promotes Maple & Co., presumably the retailers of Tottenham Court Road, London. (Cricklade Museum via Swindon Society)

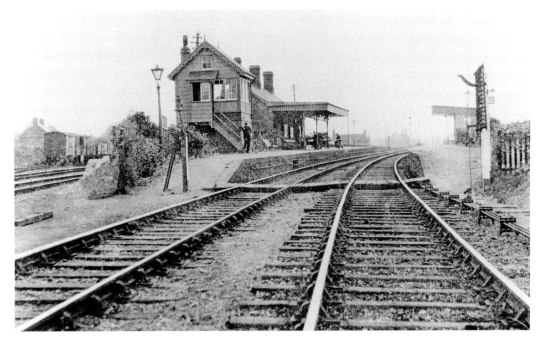

This view of the Cirencester end of Cricklade station, *c.* 1930, shows the goods yard to the left, which was served by four sidings. The signal box at the end of the Down platform was supplied by Gloucester Carriage & Wagon Co. in 1883 and had fourteen levers. Both platforms were just 312 feet (95 m) long. (Mowat Collection © Brunel University London Library via Swindon Society)

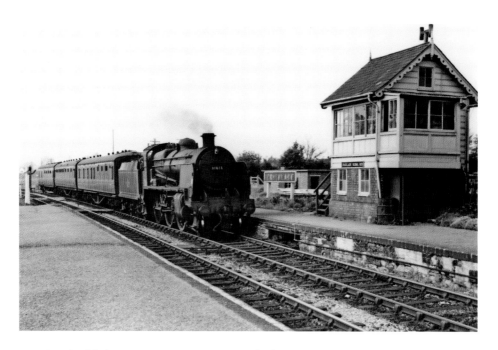

Entering Cricklade station is ex-SR U 2-6-0 tender locomotive No. 31613 with a Down train. This locomotive was allocated to Eastleigh from early 1960 and was withdrawn in 1964. The extension veranda to the signal box was added after 1944. (STEAM Picture Library)

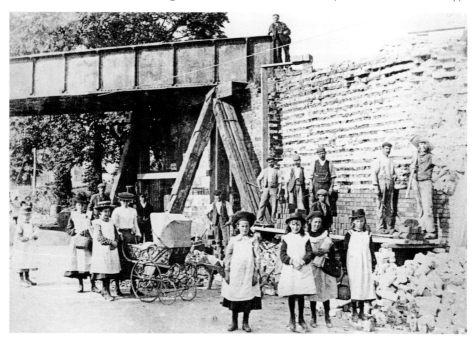

Girls in pinafores and a woman with a pram pose alongside workmen during the rebuilding of bridge No. 115 *c.* 1902. The girder bridge crossed Purton Road at the south of the town. The B4040 road now occupies the trackbed to the north-west of this point. (Cricklade Museum via Swindon Society)

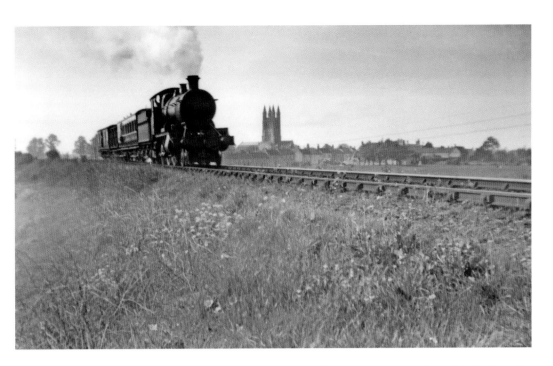

An ex-GWR 4300 Class 2-6-0 locomotive heads a southbound train away from Cricklade in the 1950s. The tower of St Sampson's Church is in the distance. The Swindon & Cricklade Railway is rebuilding its heritage line northwards towards the town. (G. Bond via Swindon Society)

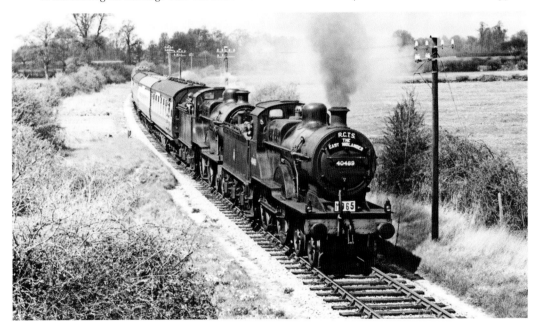

Two LMS 2P 4-4-0 locomotives (Nos 40489 and 40454) head a RCTS special train from Nottingham near Cricklade on 6 May 1956. Locomotives of this wheel arrangement were long associated with the M&SWJR, but this class of engine was not otherwise used on the line. (STEAM Picture Library)

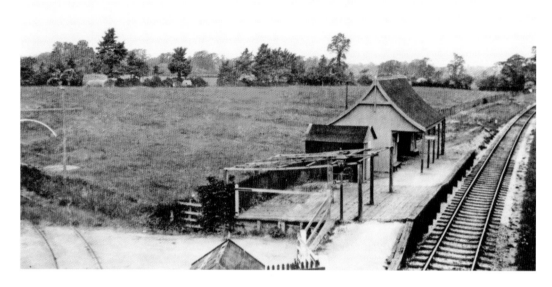

The rudimentary facilities at Blunsdon Halt are seen in this view from Tadpole Lane bridge (No. 110) in 1930. The open framework in front of the store hut and shelter was previously used for storing milk churns. (Mowat Collection © Brunel University London Library via Swindon Society)

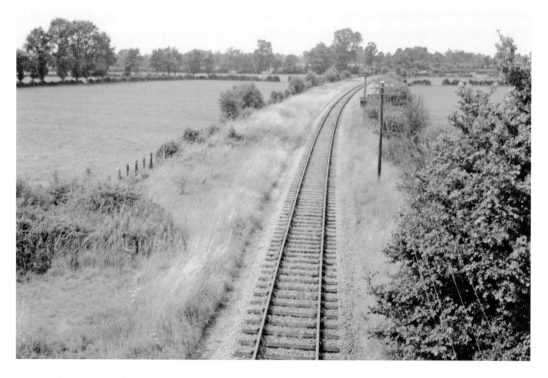

The track is still in place at Blunsdon in July 1961 but there is little evidence of the former halt that closed to passengers in September 1924. The line from Rushey Platt to Cirencester was always single track, despite doubling at the northern and southern ends of the railway. (Ben Brooksbank)

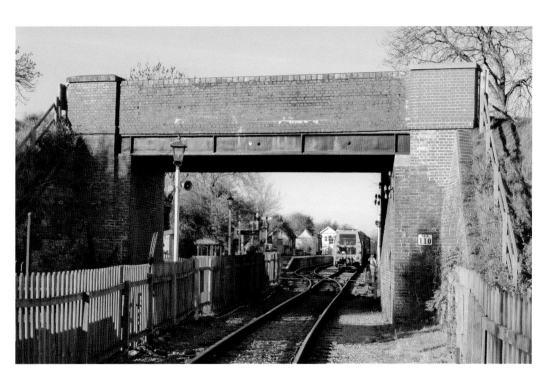

The S&CR's station at Blunsdon is seen through Tadpole Lane bridge (No. 110) in November 2017. There has been considerable development at the site since the heritage railway established its base here in March 1979. (Author)

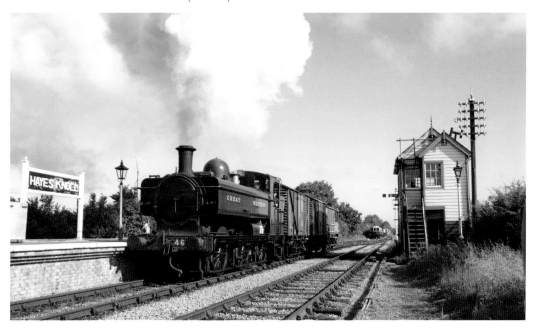

The S&CR extended northwards to Hayes Knoll in the 1990s, where visiting GWR 0 6-0PT No. 4612 stands on 17 June 2010. The GWR signal box of 1887 was recovered from Rowley Regis, near Birmingham, which closed in 1990. (P. Chancellor/Colour-Rail.com)

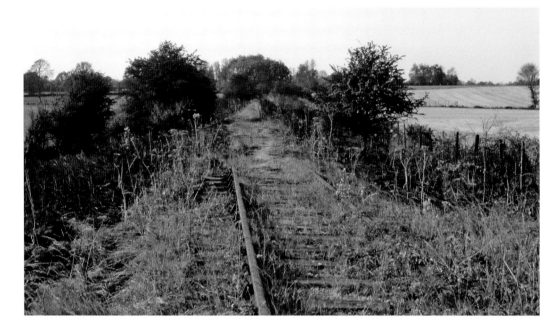

Moredon was the northern limit of the remaining track from Rushey Platt in August 1976. It had been retained with the expectation of the nearby closed power station being re-opened as an oil burning facility, but this was demolished in September 1979 without conversion from coal burning. (Peter Russell)

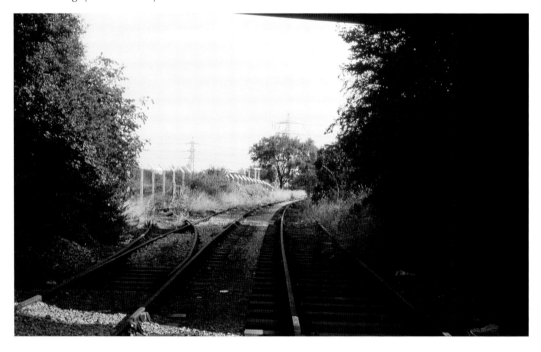

Moredon platform was established by bridge No. 103 in March 1913 for milk traffic. It officially closed to passengers in 1932, though no service was previously advertised. The site is seen in August 1976, looking south with the power station siding on the left. (Peter Russell)

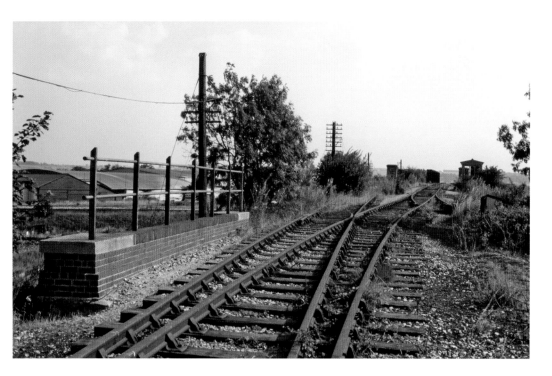

The line north from Rushey Platt crossed the GWR main line from Swindon to Chippenham, west of Swindon Junction station. This is the view looking south from the Wootton Bassett road bridge (No. 92) towards the girder bridge over the GWR (No. 91) in August 1976. (Peter Russell)

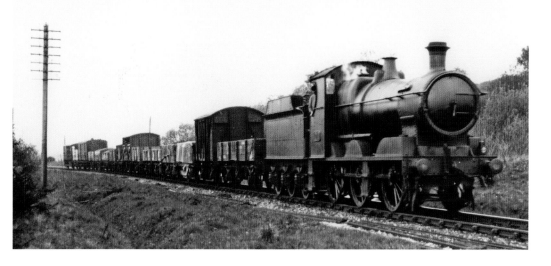

Ex-M&SWJR 0-6-0 No. 1013 (formerly No. 28) heads a freight train near Rushey Platt. The locomotive was rebuilt with a taper boiler in December 1927 and was withdrawn in June 1937. Goods traffic to Swindon Junction from the M&SWJR route was reinstated following takeover by the GWR. (STEAM Picture Library)

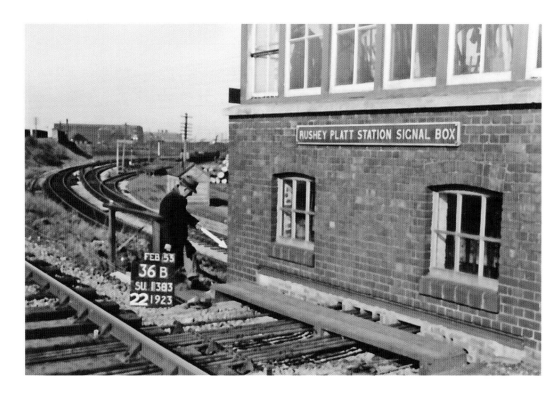

This view of Rushey Platt station signal box is from a series of Ordnance Survey images from 1953 held by Swindon Libraries, known as 'Man with a Stick', which indicate the map reference for a specific location. It shows the line to Swindon Junction behind and curving away to the right. (Local Studies, Swindon Libraries)

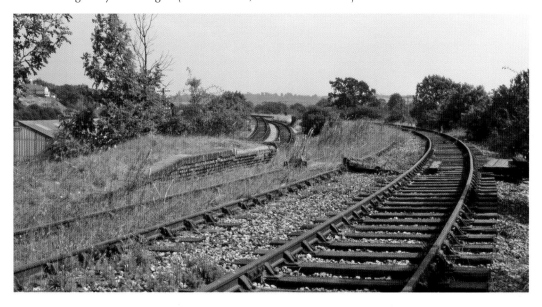

Looking south-east from the site of Rushey Platt High Level station, the line from Cirencester, in the foreground, is still intact in August 1976, as are the tracks leading towards Swindon Junction in the middle distance behind the remains of the platform. (Peter Russell)

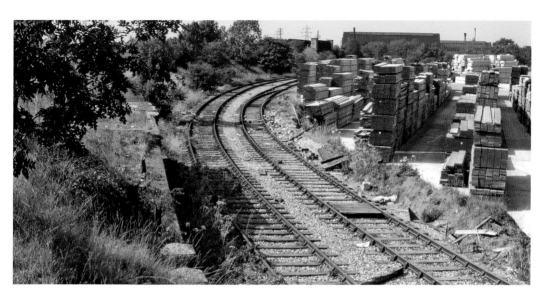

A post-closure view looking north in August 1976 shows the tracks toward Swindon Junction still in place, curving past the timber yard at Rushey Platt. A sawmill is recorded on this site from at least 1900. On the left are the remains of the high level platform and the base of the signal box. (Peter Russell)

Another 'Man with a Stick' view; this one shows the skew bridge (No. 88) over the Wilts & Berks Canal between Rushey Platt and Swindon Town station, which survives as part of a public walkway. (Local Studies, Swindon Libraries)

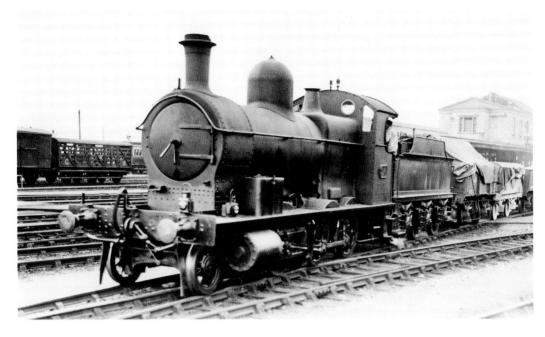

Unlike the M&SWJR's first 2-6-0 locomotive – No. 14, which ended its days in collieries in the north-east of England – the second, No. 16, became GWR No. 24 and was rebuilt with a new boiler in February 1925. It hauled pick-up goods between Swindon Junction and Stoke Gifford (Bristol) until it was withdrawn in July 1930. (STEAM Picture Library)

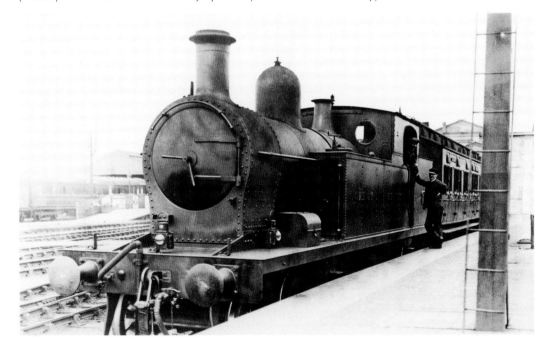

Following the Grouping in 1923, the GWR reinstated the shuttle service between the two Swindon stations. Ex-M&SWJR 4-4-4T No. 25 (originally No. 17), pictured standing at Swindon Junction station, was used on the shuttle trains from 1925 to 1927. (STEAM Picture Library)

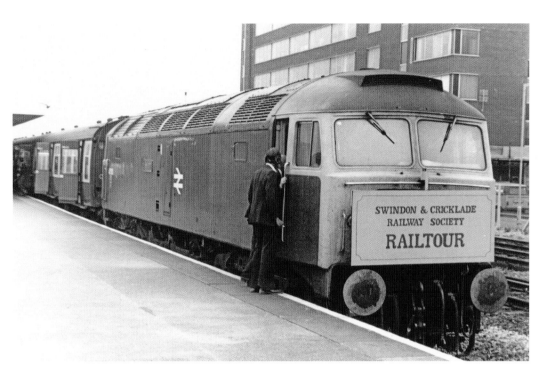

Although it did not travel on any of its tracks, this railtour of 9 September 1979 was connected with the M&SWJR, raising funds and publicity for the Swindon & Cricklade Railway Society. The train, hauled by Class 47 diesel No. 47513 *Severn,* ran from Swindon to Paignton for the Torbay Steam Railway. (Author's collection)

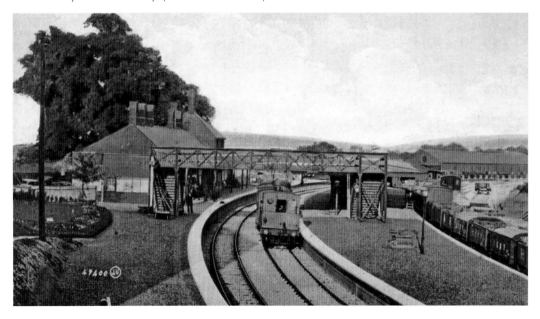

A hand-coloured version of a postcard showing Swindon Town after alterations to the station layout. This view eastwards, of around 1905, shows the station buildings on the left-hand Down side, the platform and the footbridge of 1885 to the island platform. (Swindon Museum & Art Gallery)

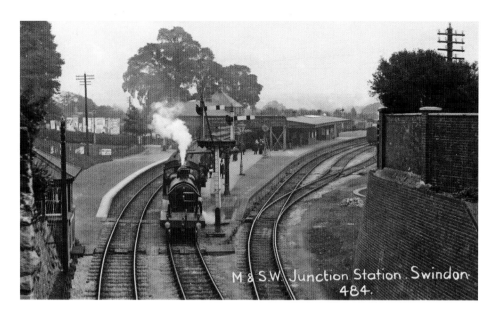

Another view of the M&SWJR station at Swindon from the Devizes Road bridge (No. 82), with an Up train leaving behind a M&SWJR 4-4-0 tender locomotive, probably during the First World War. The L&SWR type signal box of 1905 can be seen on the extreme left. (Swindon Museum & Art Gallery)

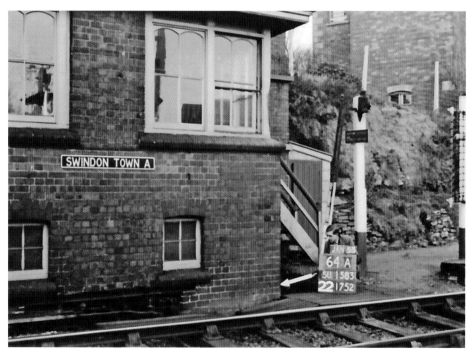

An Ordnance Survey record photograph featuring the corner of the Swindon Town A signal box in January 1953. The GWR standard token apparatus for single line working was installed in 1928, with trackside stands, as seen next to the surveyor. (Local Studies, Swindon Libraries)

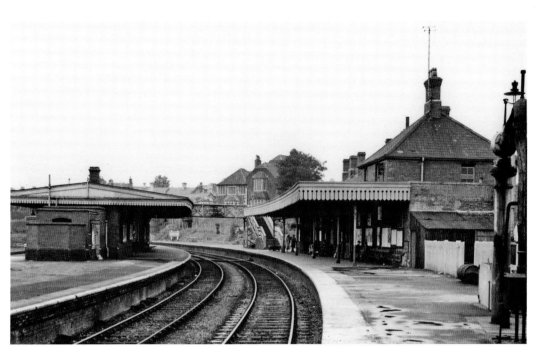

With no trains in the station, the Up and Down platforms (left and right respectively) and station buildings can be clearly seen in this view looking west. The station was opened for traffic to Marlborough on 27 July 1881. (Swindon Museum & Art Gallery)

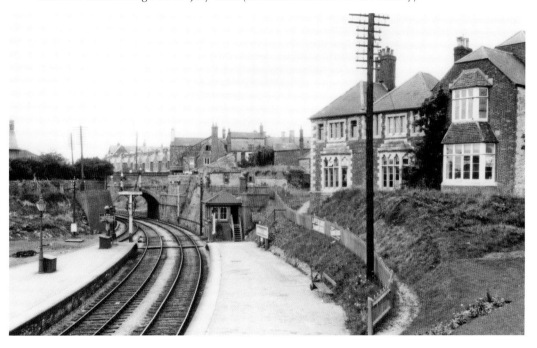

The M&SWJR headquarters, at the Croft from 1881 to 1924, were alongside the Down platform at Swindon Town, as seen in this 1950 view. The left-hand wing was demolished in the early 1950s. (STEAM Picture Library)

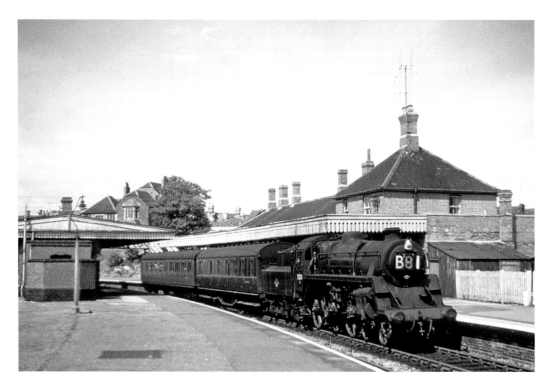

In addition to former GWR and SR engines, BR Standard Class locomotives were also employed on M&SWJR route trains during the final years of the line. BR 4MT Class 4-6-0 No. 75029 stands at Swindon Town with a Down train on 21 August 1960. (R. Denison/Colour-Rail.com)

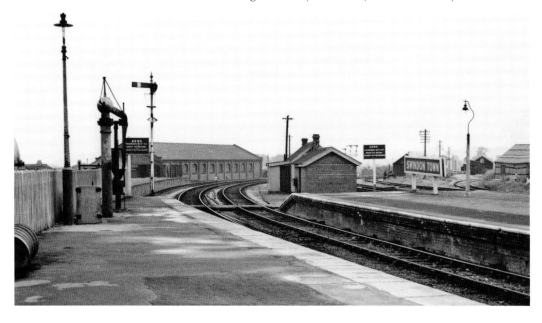

Looking east from the Down platform, the goods shed at Swindon Town can be seen beyond the station. The buildings at the end of the Down platform were the lamp room and an office for permanent way staff and the traffic inspector. (Swindon Museum & Art Gallery)

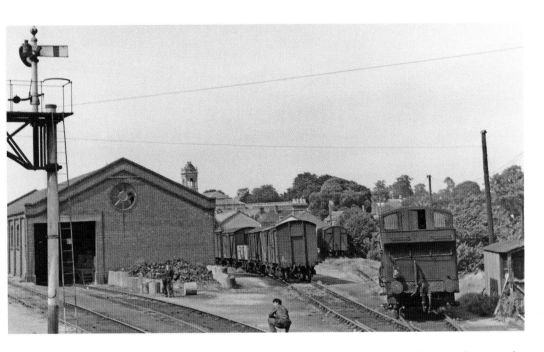

Seen from a passing train on 27 July 1961, ex-GWR 0-6-0PT No. 4697 is in attendance at the goods yard at Swindon Town. The goods shed was 150 feet (45.7 metres) long and 41 feet (12.5 metres) wide. The tower of the Corn Exchange of 1852 is seen above the shed roof. (James Harrold/Transport Treasury)

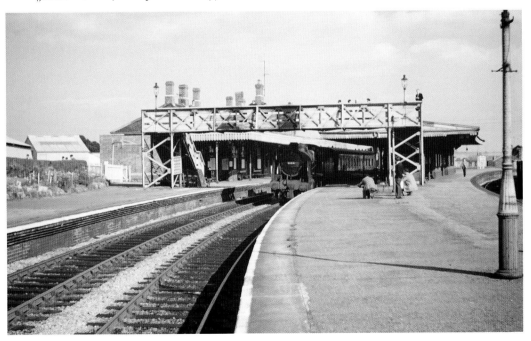

An ex-SR N Class 2-6-0 tender locomotive, No. 31816, heads an Up passenger train in Swindon Town on 9 September 1961, the last day of regular services north of Swindon. Swindon was one of only three M&SWJR stations with a footbridge; the others were Savernake and Tidworth. (Colour-Rail.com)

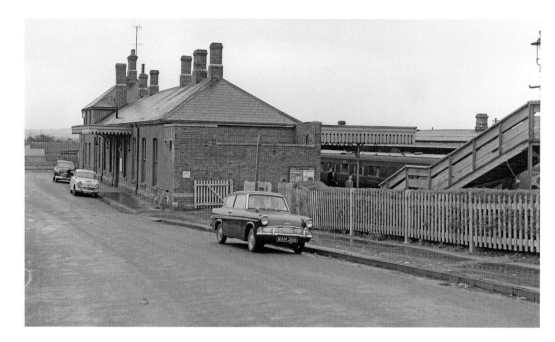

Period vehicles parked on the approach road to Swindon Town station on the last day of services on 10 September 1961 are a Standard Vanguard Phase 1 (*c.* 1951), a 1957 Austin A55 Cambridge and a Ford 105E Anglia from 1960. The carriage at the Up platform, just visible by the footbridge steps, is a cafeteria car. (Leslie Reginald Freeman/Transport Treasury)

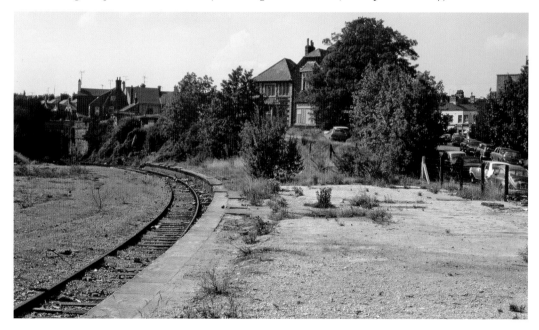

The former M&SWJR headquarters survived closure in part and are seen here looking north-west from the derelict Down platform in August 1976. The track was reinstated in 1970 for roadstone traffic. The last passenger train to Swindon Town was a DMU enthusiasts' special on 16 April 1972. (Peter Russell)

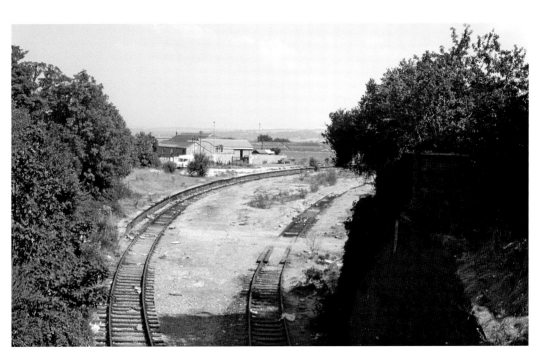

The remains of Swindon Town station, looking east from the Devizes Road bridge (No. 82), in August 1976. Within a few years members of Swindon & Cricklade Railway Society would recover platform edging stones for use at the embryonic heritage railway at Blunsdon. (Peter Russell)

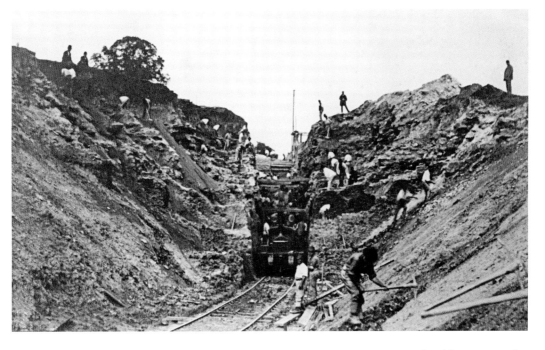

Messrs Watson, Smith & Watson's men are seen excavating a cutting at Chiseldon, *c.* 1879, for the SM&AR's line from Swindon to Marlborough. The small contractor's locomotive was used to haul spoil away. (G. E. Lait via Swindon Society)

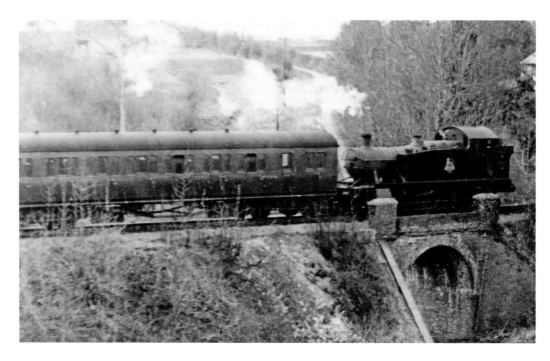

Heading towards Swindon, an ex-GWR 4575 Class 2-6-2T, with an early BR emblem, crosses Cuckoo Bridge (No. 74), north of Chiseldon station. (Swindon Society collection)

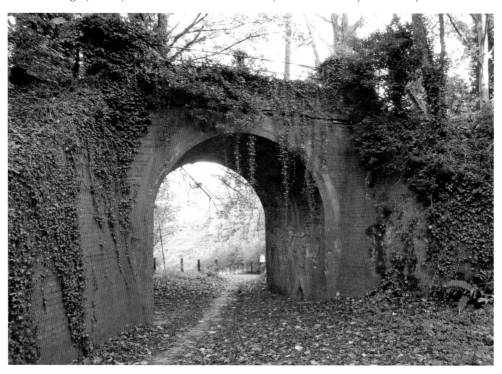

Cuckoo Bridge still stands within private woodland near Chiseldon, crossing the footpath between Mount Pleasant and Washpool, and is seen here in November 2017. (Author)

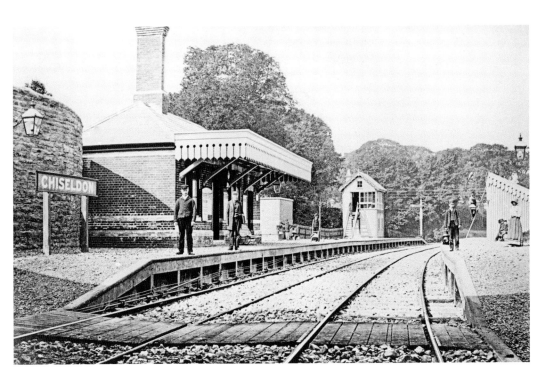

This view of Chiseldon station soon after completion in 1881, looking north-west from by the road bridge, shows the SM&AR building with its original tall chimney and signal box on the Up platform. (G. E. Lait via Swindon Society)

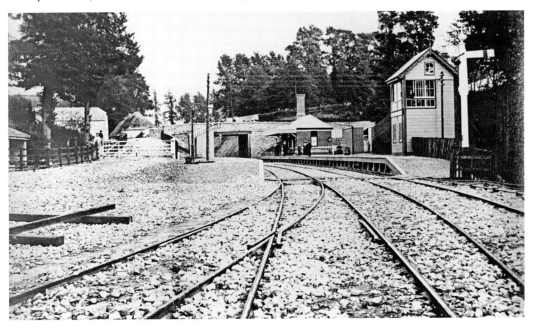

Chiseldon station, looking south-east from the entrance point for the original goods yard in 1881. The signal box was supplied by the Gloucestershire Railway Carriage & Wagon Co. The road bridge (No. 72) is beyond the station building. (G. E. Lait via Swindon Society)

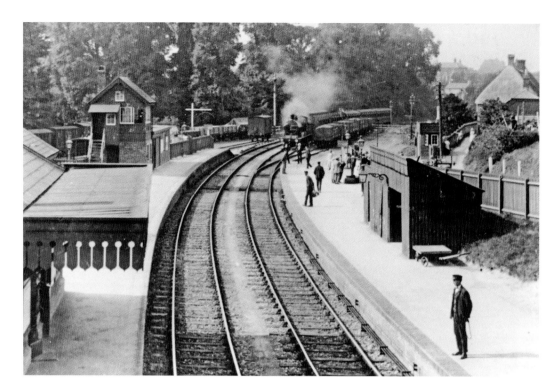

Looking towards Swindon from High Street bridge No. 72 at Chiseldon, a Down train is approaching the station. The sidings on the Up side were added in 1905 and the goods store beyond the signal box in 1920. (Swindon Society collection)

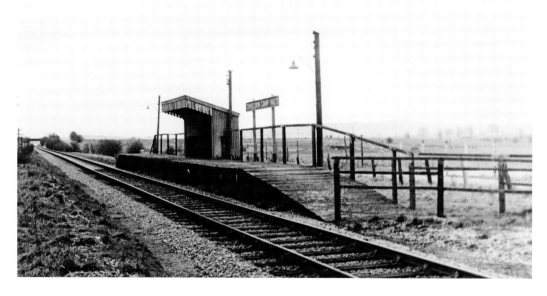

The wooden platform at Chiseldon Camp Halt was provided in December 1930 on the west side of the single track to Marlborough. In this March 1958 view looking south, the overbridge at South Farm (No. 69) is seen in the distance. (H. C. Casserley via Swindon Society)

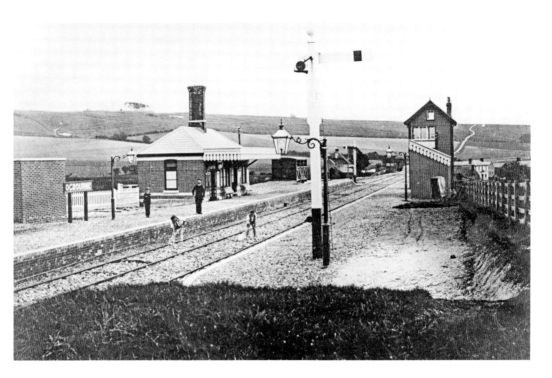

Ogbourne station, in the parish of Ogbourne St George, was opened for passengers on 27 July 1881 on the SM&AR as a passing place on the single track line. The station building, on the Down platform, was similar to that at Chiseldon. This early view is looking south to Marlborough. (G. E. Lait via Swindon Society)

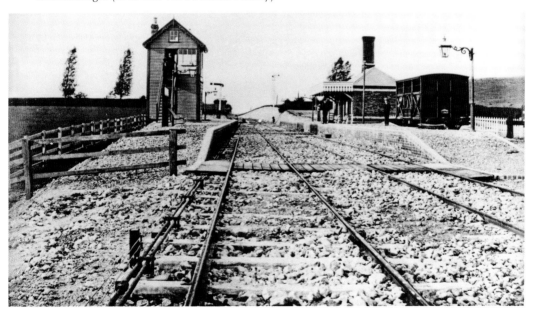

Looking towards Swindon, the original signal box stands tall on the Up platform at Ogbourne in 1881. The cattle wagon in the horse dock was built for the SM&AR by the Metropolitan Railway Carriage & Wagon Co. (G. E. Lait via Swindon Society)

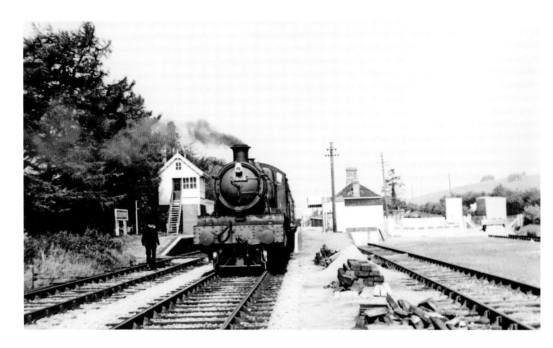

Ex-GWR 4-6-0 No. 7808 *Cookham Manor* heads a Down train at Ogbourne in September 1956. This locomotive was the last of its class to run on the line, and was also probably the first, in 1941. (H. C. Casserley via Swindon Society)

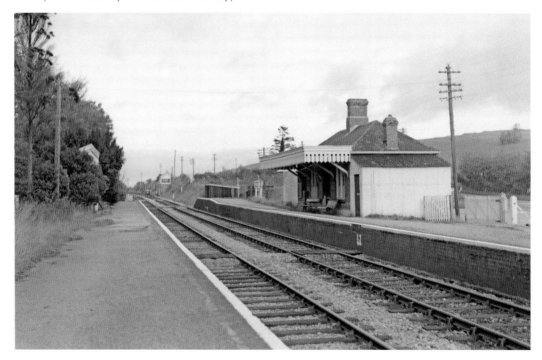

The chimney of Ogbourne station's building had been reduced in height by the time of this October 1959 view of the station from the Up platform. The standard GWR replacement signal box beyond the Down platform was built by US troops in 1943. (James Harrold/Transport Treasury)

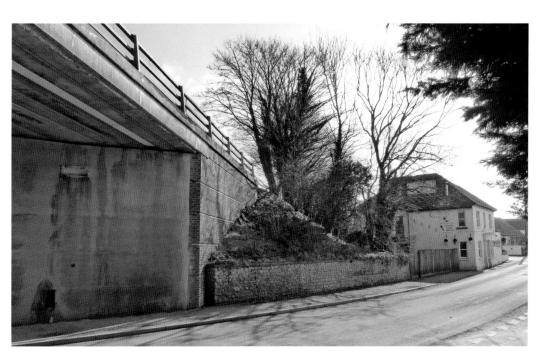

Following closure, the trackbed at Ogbourne was used to provide the village with a bypass. A road bridge now carries the A346 where M&SWJR underline bridge No. 65 once stood next to the Crown Inn (now the Inn with the Well). (Author)

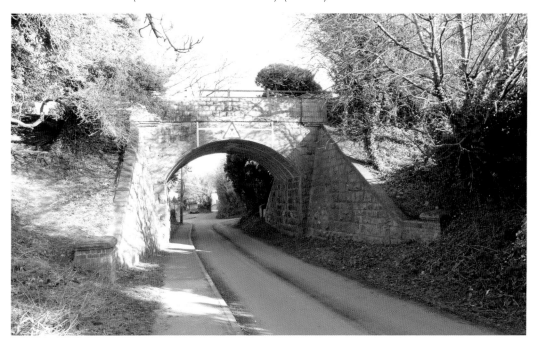

Several former M&SWJR bridges, both over and under the line, survive on the Chiseldon & Marlborough Railway path. The Up side of bridge No. 53, over Buck Lane just north of Marlborough, is seen from the west in February 2018. (Author)

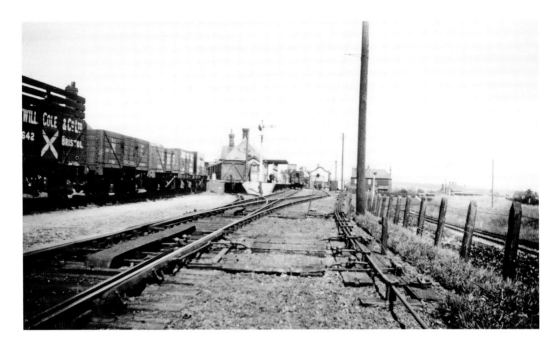

The first station at Marlborough opened on 14 April 1864, at the end of the then broad gauge branch from Savernake. This view, taken in 1927, shows the station in the middle distance, with the engine shed beyond. The M&SWJR (originally M&GR) line is behind the fencing on the right. (Mowat Collection © Brunel University London Library via Swindon Society)

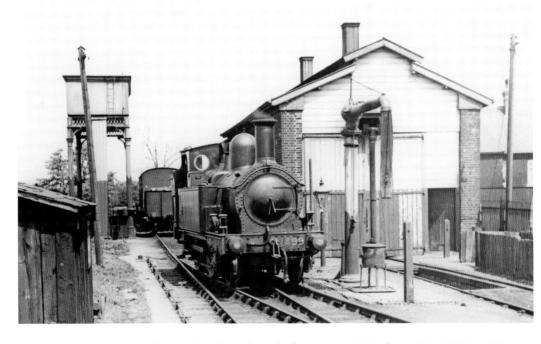

The GWR operated the Marlborough Railway from the beginning. GWR Class 455 2-4-0T No. 1499 (built 1892) stands alongside the single-road engine shed at Marlborough (High Level from 1924) in May 1929. The station closed to passengers in 1933. (H. C. Casserley via Swindon Society)

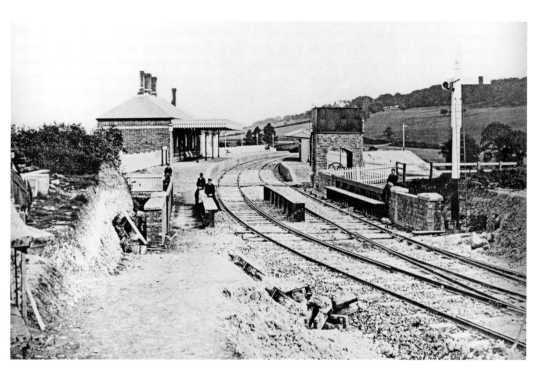

The SM&AR station at Marlborough is seen from the south-east soon after completion in 1881. The substantial station building on the Up platform, with its typical tall chimneys, had a refreshment room added in 1884, which survived until the railway closed. (G. E. Lait via Swindon Society)

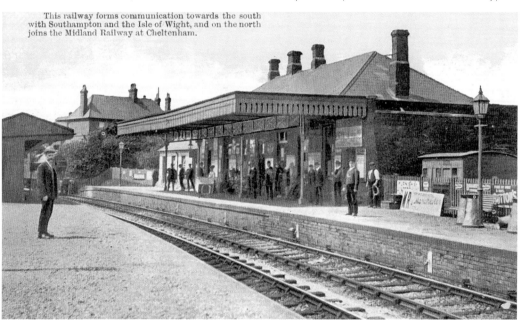

This railway forms communication towards the south with Southampton and the Isle of Wight, and on the north joins the Midland Railway at Cheltenham.

A hand-coloured view of Marlborough station, *c.* 1912. A northbound train headed by an M&SWJR 4-4-0 locomotive is approaching the Up platform as the station staff pose for the photographer. (Wiltshire & Swindon History Centre)

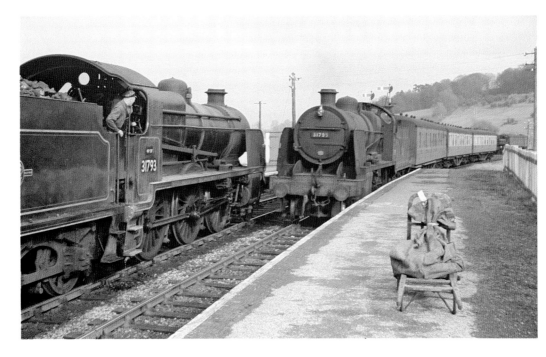

Ex-SR U Class 2-6-0 locomotives pass with trains at Marlborough Low Level; No. 31793 stands on the Up line while No. 31795 approaches with a Down train. Both engines were allocated to Eastleigh shed from October 1958. (D. Cross/Colour-Rail.com)

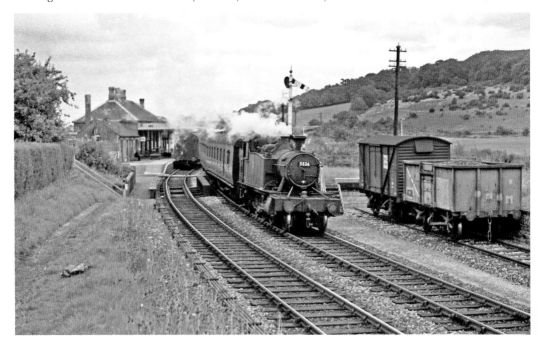

GWR 2-6-2T locomotive No. 5536 leaves Marlborough Low Level station with a Down local passenger train on 21 August 1960. The small goods yard was on the Up side of the station, while the siding on the right served a loading platform on the Down side. (Colour-Rail.com)

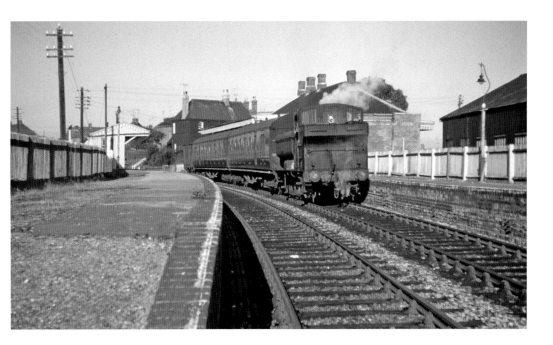

Ex-GWR pannier tanks handled many of the local trains between Savernake and Marlborough in the final years of the line, as seen at the Up platform in September 1961. The black painted goods shed is behind the platform. (Colour-Rail.com)

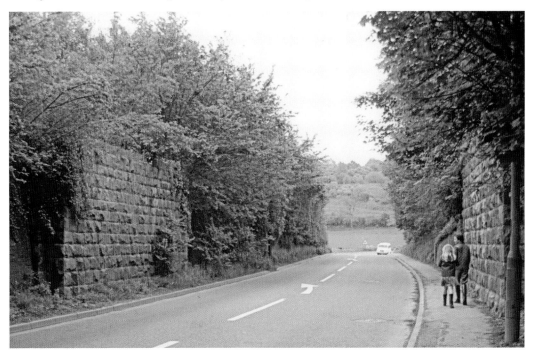

Looking south along the A346 road from Marlborough, *c.* 1980s, the remains of the abutments of underline bridge No. 50 are lasting evidence of the railway. The girder underline bridge was immediately south of the low level station. (Swindon Society collection)

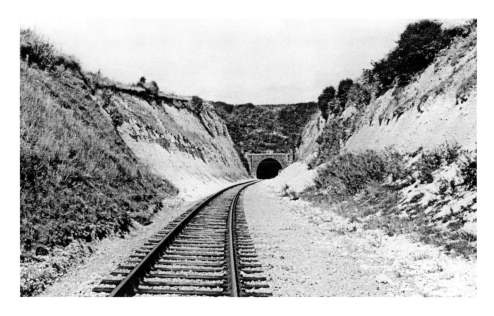

The southern portal of Marlborough Tunnel (bridge No. 48), as seen after the removal of the former Down line in 1960. The inscribed keystone records the inaugural ceremony on 2 July 1898. (Swindon Society collection)

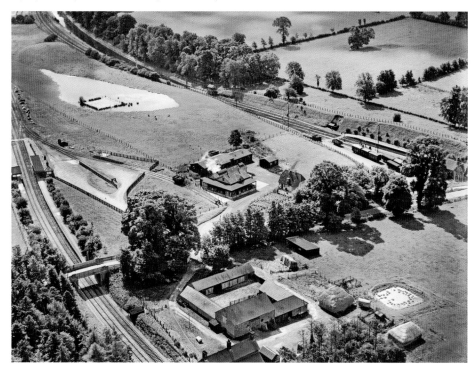

This aerial view from 1934 of the two stations at Savernake shows how closely the competing railways ran. On the left is the former M&SWJR station (High Level from 1924) and to the south-west of this, and running along the top of the image, is the GWR (low level) station. Between is the Wiltshire Farmers milk depot. (Britain from Above © Historic England)

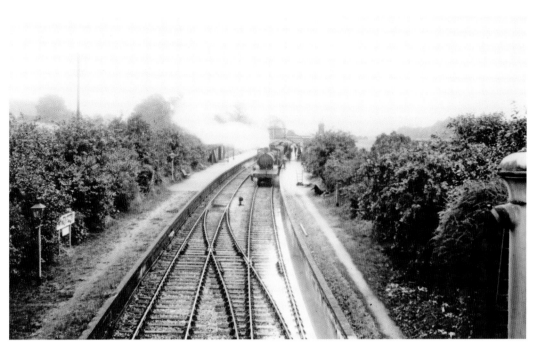

The Marlborough & Grafton Railway station at Savernake (later High Level), looking south-east from the road bridge (No. 38); the approaching train is heading towards Marlborough. The footbridge between the platforms is just visible beyond the locomotive. (Swindon Society collection)

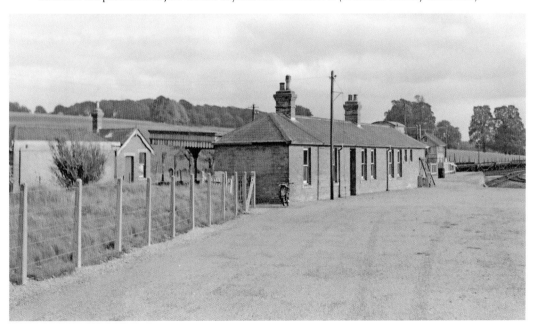

The former M&SWJR station at Savernake was opened in June 1898, with the M&GR line from Marlborough. This view from the approach road, dated 1959, shows the station building on the Up side and beyond, on the opposite platform, the Marquess of Ailesbury's private waiting room. (James Harrold/Transport Treasury)

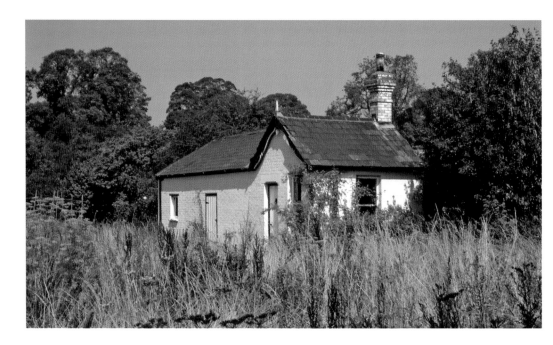

In exchange for land rented to the Marlborough & Grafton Railway, the Marquess of Ailesbury required that a private waiting room was provided on the Down platform at Savernake. It is seen here in August 1976, having survived closure along with other structures at the high level station. (Peter Russell)

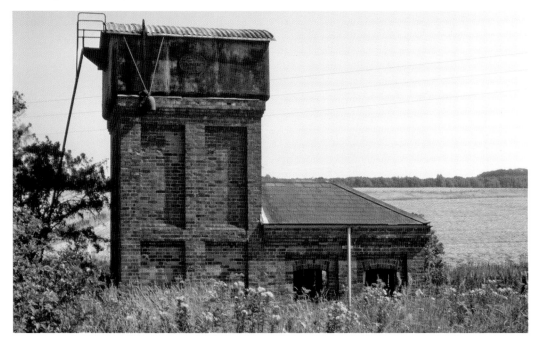

The water tank, and its adjoining pump house, at the M&SWJR station at Savernake were sited at the south-east end of the Down platform, just before the signal box. The surviving water tower is seen here in 1976; the tank was fitted with a corrugated iron cover in 1917. (Peter Russell)

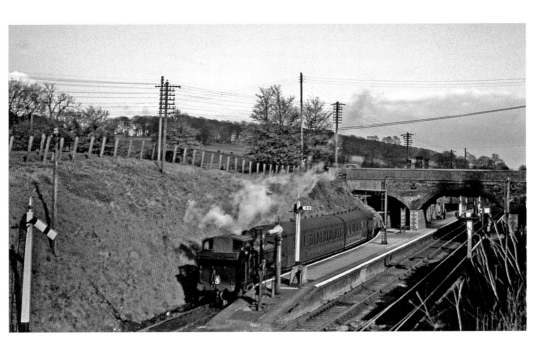

From 1933 branch line trains from Savernake low level ran to Marlborough Low Level via a connection at Hat Gate to the former Up line of the M&SWJR. A branch line train, headed by ex-GWR 0-6-0PT No. 3684, stands in the bay platform at Savernake on 6 April 1957. (N. Sprinks/Colour-Rail.com)

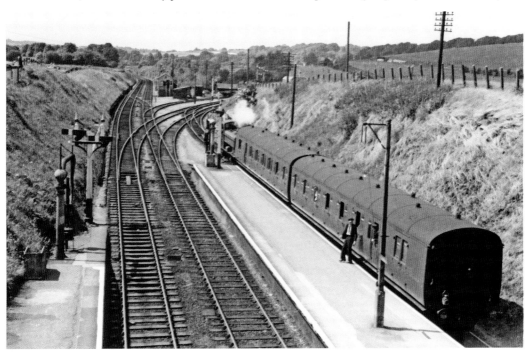

This view of Savernake Low Level station, looking north-west from the Stibb Green to Durley road bridge, shows the double track of the Berks & Hants line bearing left towards Westbury. The branch line to Marlborough curves right beyond the bay platform. (Lens of Sutton via Swindon Society)

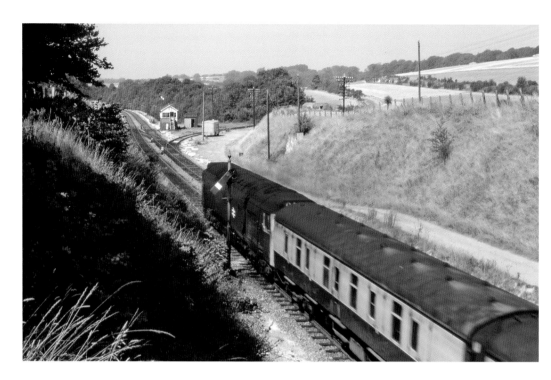

Savernake Low Level station with a Class 50 diesel on a westbound Berks & Hants line train on 19 August 1976. The remains of the bay platform and line to Marlborough are to the right, before the GWR Savernake West signal box. A line of vegetation marks the route of the M&GR on the right. (Peter Russell)

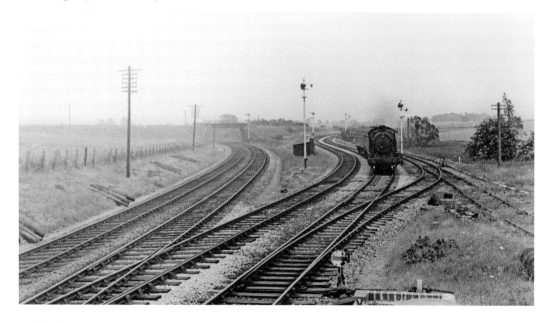

Wolfhall Junction (GWR), as seen from Grafton South signal box with a train on the line from Grafton, *c.* 1956. The Berks & Hants Extension line tracks curve away to the left towards M&SWJR bridge No. 36. (T. B. Sands via Swindon Society)

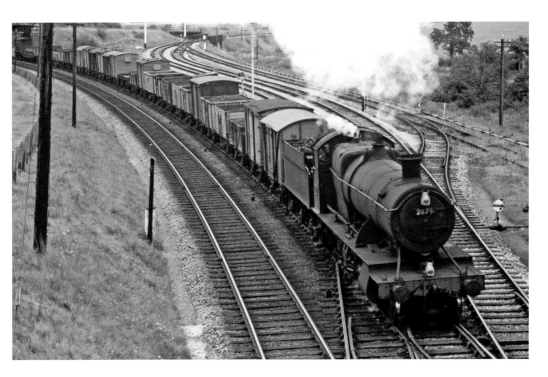

Ex-GWR 2-8-0 No. 2879 negotiates Wolfhall Junction (GWR) with a westbound freight from the Berks & Hants line on 1 September 1958. The tracks to the right led to Grafton South Junction. (T. Owen/Colour-Rail.com)

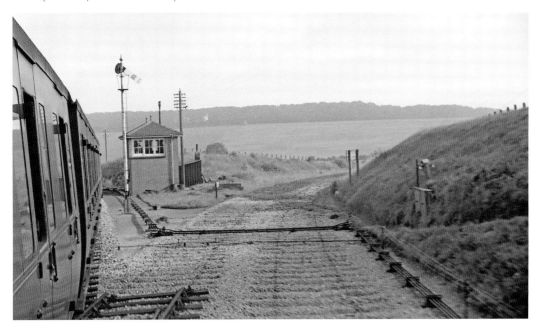

Grafton South Junction, formerly Wolfhall Junction (M&SWJR), as seen from a southbound train in July 1960. The trackbed of the Grafton East Curve, removed in May 1957, bears to the right of the L&SWR-design signal box of 1905. (Norris Forrest/Transport Treasury)

By August 1976 only the trackbed of the lines at Grafton South Junction remained. In the distance a Berks & Hants line train is hauled westwards by a Class 47 diesel locomotive. On the hill beyond to the north is Langfield Copse. (Peter Russell)

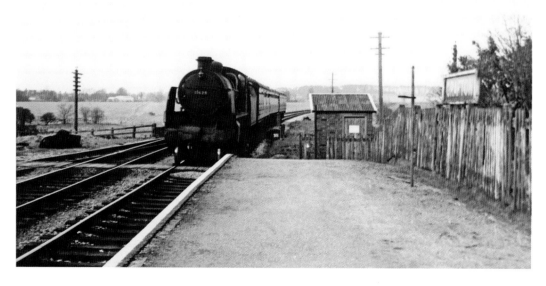

SR U Class 2-6-0 No. 31639 enters Grafton station with a southbound train in 1958. The station opened on 1 May 1882 with a service to Andover Junction, pending agreement to use the Marlborough Railway's route north. (H. C. Casserley via Swindon Society)

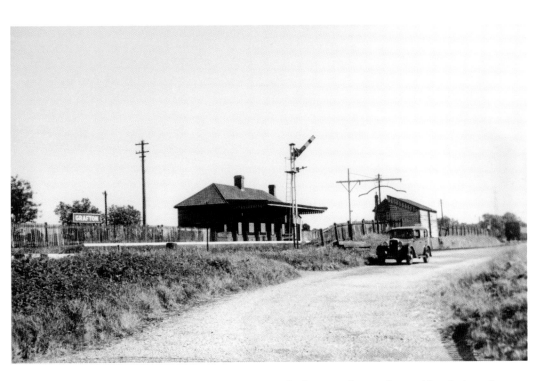

Grafton's station building was on the Down platform, and was almost identical to those at Collingbourne and Weyhill. Mr Casserley's Hillman car is once again seen, behind the Up platform and its shelter, in July 1959. (H. C. Casserley via Swindon Society)

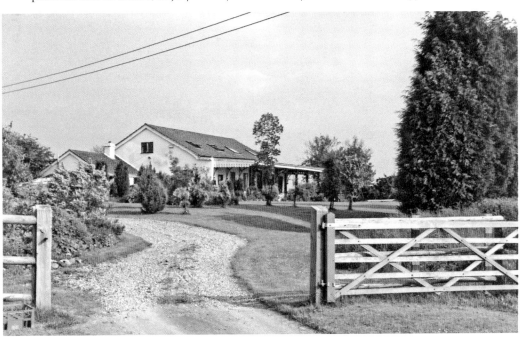

Grafton station building survives, although much altered, and remains in residential use. It is seen here in June 1994, over thirty years after closure. (Ben Brooksbank)

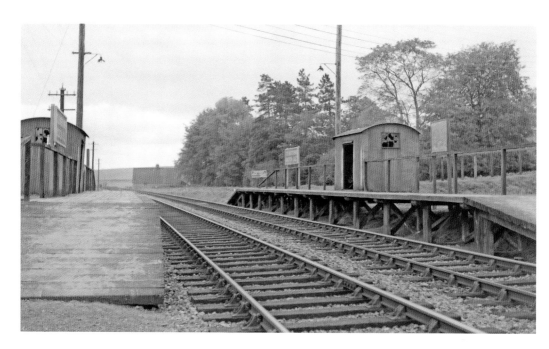

Collingbourne Kingston Halt was opened on 1 April 1932 to try to combat increasing competition from road transport. The halt was provided with very basic amenities and short wooden platforms, and is seen here in October 1959. (James Harrold/Transport Treasury)

The site of Collingbourne Kingston Halt looking from the partially filled-in road bridge (No. 24) in November 2017. When open, tickets could be purchased from a nearby house. (Author)

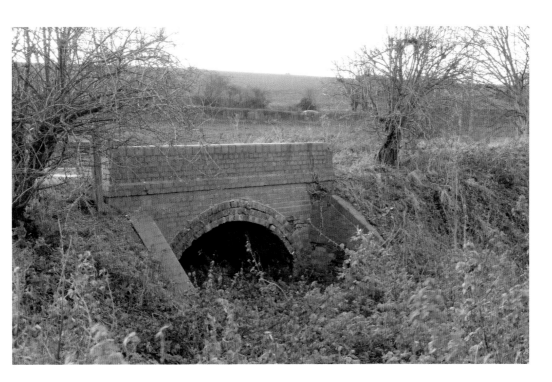

Despite closure of the line fifty-six years before in 1961, there is still much physical evidence of the route. This is underline bridge No. 22, near Collingbourne Kingston, as seen in November 2017. (Author)

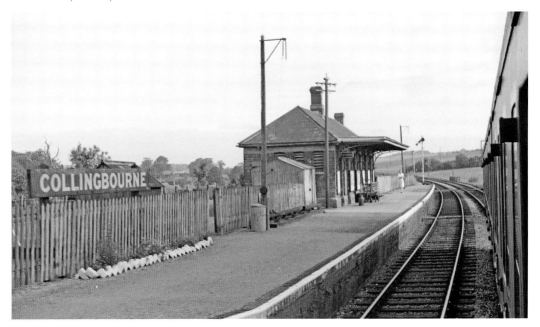

The station building at Collingbourne is seen from a Down train in June 1960. The station was built by contractor John Dover and opened in May 1882 with the SM&AR from Grafton to Andover. (Norris Forrest/Transport Treasury)

The Last Train To Collingbourne.

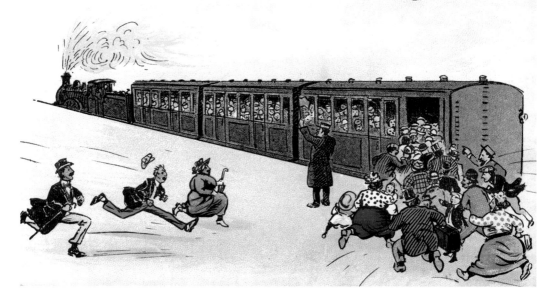

This comic postcard of the Edwardian period was perhaps prescient of events some half a century later in 1961, when the 'last trains' did indeed run to full capacity, occupied by railway enthusiasts. (Swindon Society collection)

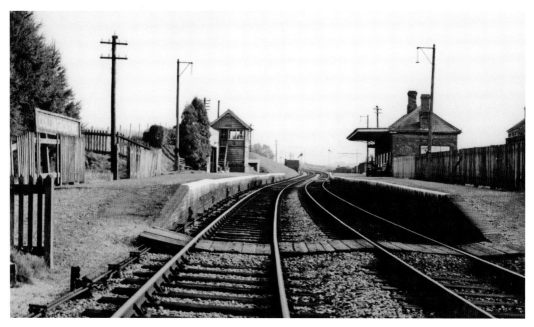

Collingbourne station was provided with a main building with a canopy on the Up platform and a signal box on the opposite one. The platforms were 302 feet (92 metres) long and, in common with many M&SWJR stations, were connected by a barrow crossing. This view is looking south. (STEAM Picture Library)

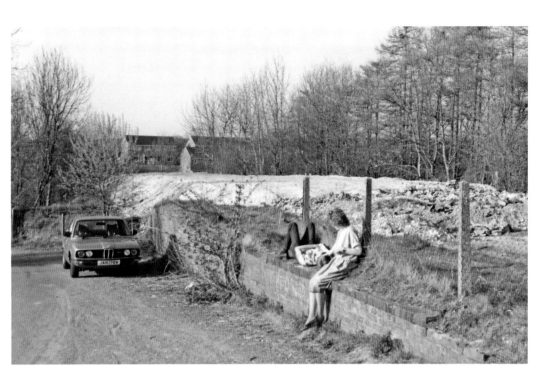

The photographer's teenage children sit on the remains of Collingbourne station in April 1984. The housing estate is beyond the now demolished bridge (No. 19) over Cadley Road. (Ben Brooksbank)

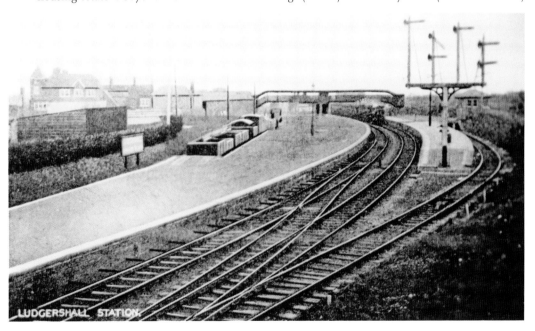

The first station at Ludgershall opened with the SM&AR in May 1882 and had just two platforms and a small goods yard. The development of military barracks in the area led to the provision of a troop platform north-west of the station by 1898 and additional wide platforms from 1901. (Swindon Society collection)

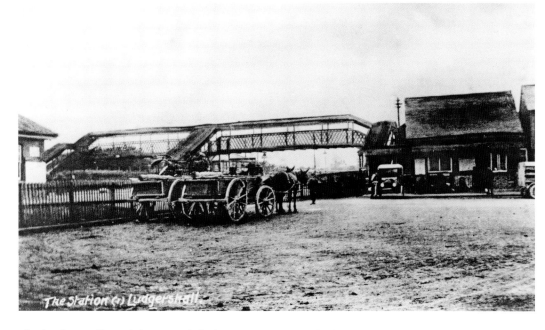

The booking office of the re-modelled station at Ludgershall was at the end of the approach road, north of the station and at a right-angle to the Down platform. It is seen on the right of this 1905 view with the footbridge serving the two main and two bay platforms to its left. (Swindon Society collection)

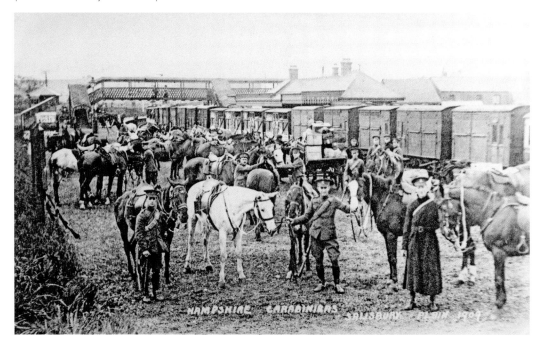

The Up platform at Ludgershall is occupied by troops of the Hampshire Yeomanry (Carabiniers) in 1909. Only officers' horses qualified for horseboxes; cattle wagons sufficed for other ranks' mounts. (Swindon Society collection)

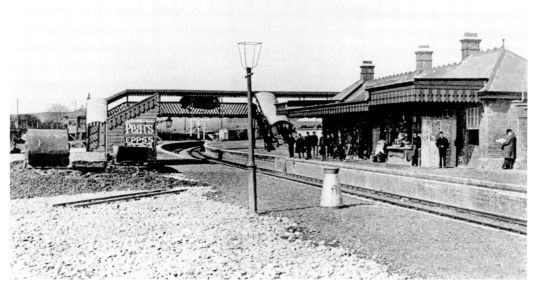

This view, looking west from the Up platform, shows the main station building on the Down platform. The footbridge, installed in 1902, also spanned the long Down siding. The signal box and short Tidworth branch bay were to the left of the footbridge. (Swindon Society collection)

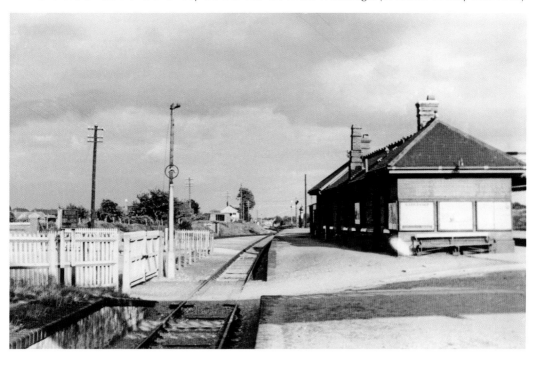

Looking east from near the footbridge towards the station building, the track on the left served a 775 foot (236 metres) long bay platform on the Down side. The main Down platform was 943 feet (287 metres) long while the Up was only 735 feet (224 metres). (H. C. Casserley via Swindon Society)

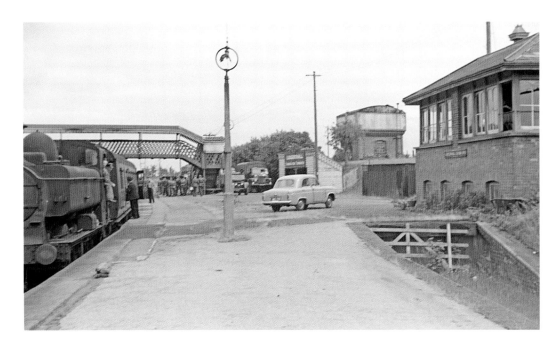

Military activity on the Up main line platform is evident beyond the footbridge, alongside the GWR pannier tank-hauled train and beyond the Ford Prefect 100E car, in this July 1960 view. The end of the Tidworth branch bay platform is just in front of the signal box. (Norris Forrest/Transport Treasury)

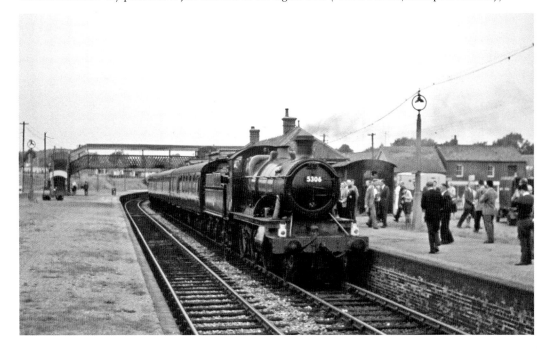

GWR 2-6-0 No. 5306 stands at the Down platform at Ludgershall with the RCTS (London Branch) 'Farewell to the M&SWJR' special train on 10 September 1961. The train originated at Birmingham and was steam-hauled from Swindon (Junction) to Andover Junction, then north to Cheltenham and returned to Swindon via Stroud. (Colour-Rail.com)

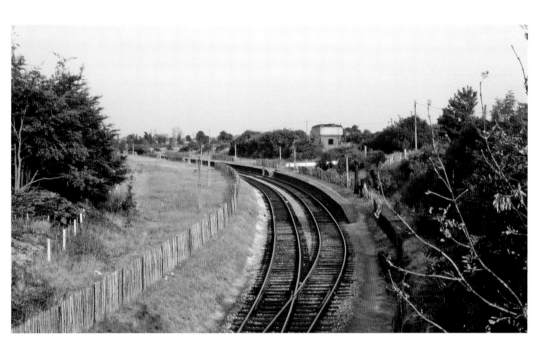

Looking south-east from bridge No. 12 in August 1976, the remains of Ludgershall's wide platforms were still visible. The 10,000 gallon (45,461 litre) water tank is prominent behind the Up platform but the L&SWR-style signal box has been demolished. (Peter Russell)

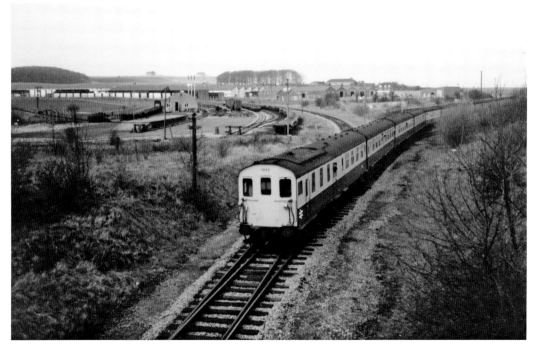

Several steam- and diesel-hauled special trains have run to Ludgershall since closure of the M&SWJR as a through route. Seen leaving the 'horse platform', DEMUs Nos 1032 and 1017 form Hertfordshire Rail Tours' Thames Piddle Executive on 19 March 1983. (Swindon Society collection)

Ludgershall depot continues in use for military purposes but there had been no train in the four months prior to this view looking south-east along the 'horse platform' in November 2017. At the beginning of 2017, an armoured fighting vehicle was loaded onto a train for transportation through the Channel Tunnel to France. (Author)

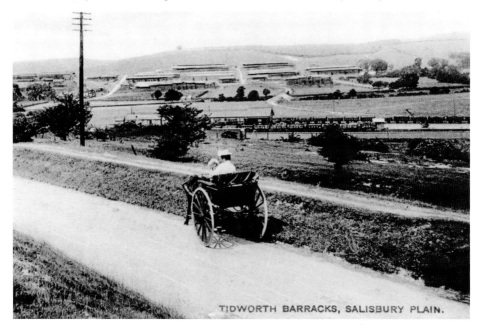

TIDWORTH BARRACKS, SALISBURY PLAIN.

Tidworth station is in the middle distance of this view looking west towards the military barracks. The military line curving away from the branch is in the middle distance. The garrison could accommodate five infantry and three cavalry battalions – around 8,000 men. (Swindon Society collection)

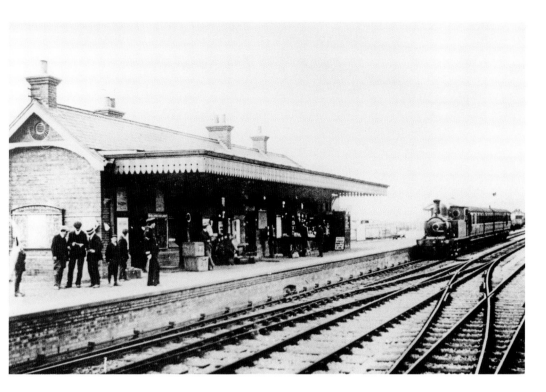

One of the M&SWJR's two 0-6-0T locomotives approaches Tidworth station before 1915. The branch was opened for military traffic in July 1901 and to public traffic from 1902, and was operated by the M&SWJR on behalf of the War Office. (Swindon Society collection)

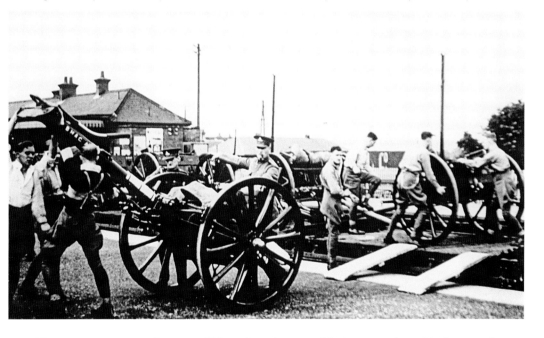

Troops manoeuvre equipment at Tidworth station, possibly in connection with the annual camp of the Honourable Artillery Company, c. 1935. (Swindon Society collection)

85

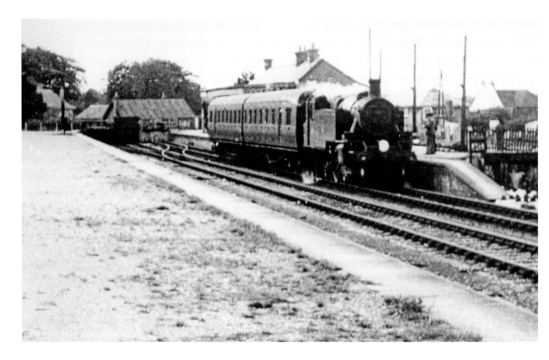

Looking from the 800 foot (243.8 metre) long troop platform at Tidworth, an ex-LMS Ivatt 2-6-2T locomotive stands with a branch train to Ludgershall. The station closed to public passengers on 17 September 1955. (Swindon Society collection)

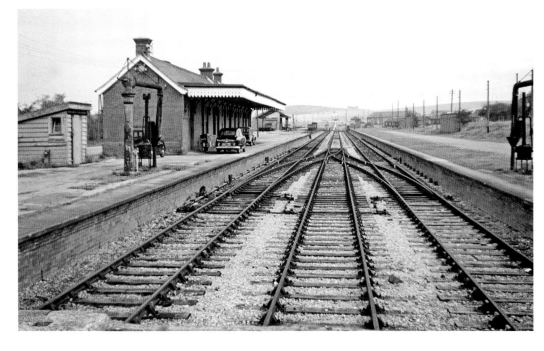

This view from the buffer stops at Tidworth in 1961 or 1962 shows the central engine release road and brick latrines on the troop platform on the far right. The branch closed completely on 31 July 1963, the last troop train running the year before. (Paul Strong via Mike Barnsley)

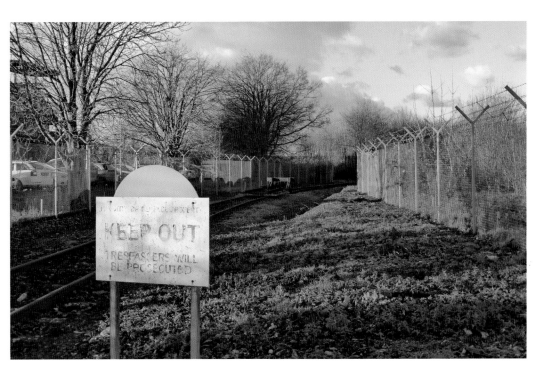

A siding turned south from the Tidworth branch at Ludgershall and curved anti-clockwise to the military vehicle depot. The depot closed in March 1997 and the remaining track, seen in November 2017, stops just north of the former A3026 level crossing. (Author)

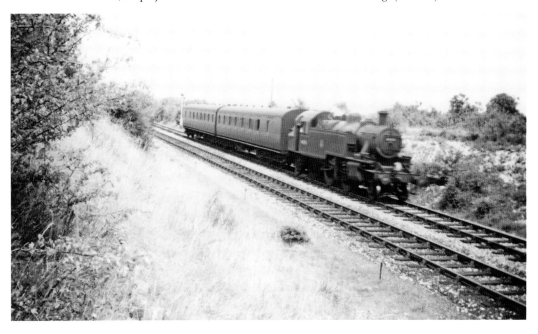

A short passenger train, headed by an ex-LMS Ivatt 2-6-2T engine (possibly No. 41293), is seen just west of Weyhill in July 1951. Southern Region-based locomotives such as this, allocated to Eastleigh shed, were used on the line from 1950. (Swindon Society collection)

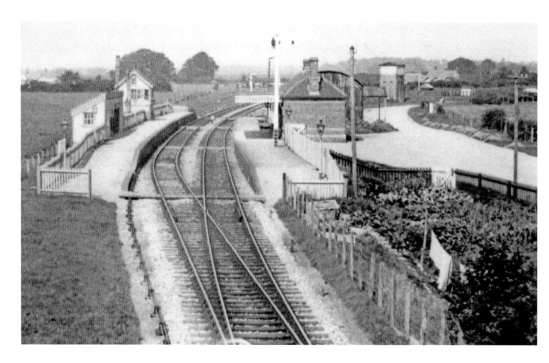

The main, brick-built station building at Weyhill was on the Down side, with the signal box on the opposite platform. The line to Ludgershall was doubled in August 1900 but remained single to Red Post Junction until 1943. (Swindon Society collection)

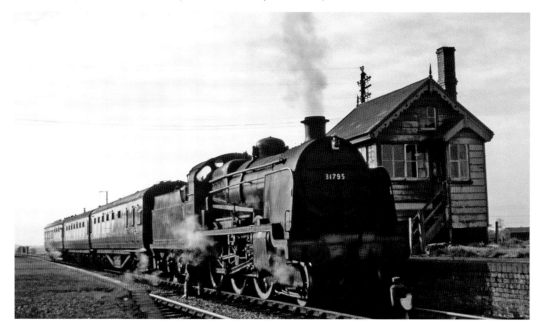

Ex-SR 2-6-0 U Class No. 31795 stands alongside the Gloucester Carriage & Wagon Co.-built signal box of 1882 at Weyhill with an Up train in 1961. The lines to Ludgershall and Red Post Junction were singled in August 1960, Weyhill reverted to a passing loop and the signal box was closed. (David A. Lawrence/Colour-Rail.com)

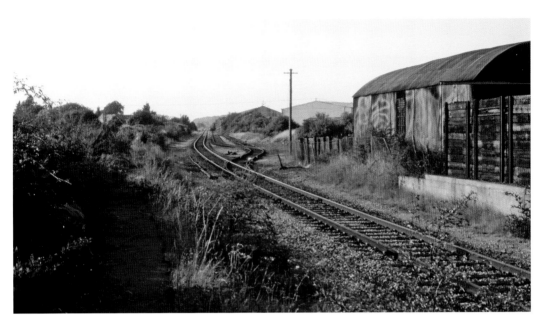

The large corrugated iron goods shed (61 feet/18.6 metres by 26 feet/7.9 metres) remained standing in August 1976, over half a dozen years after the station closed to freight in December 1969. The single track line from Andover remains in use for the military depot at Ludgershall. (Peter Russell)

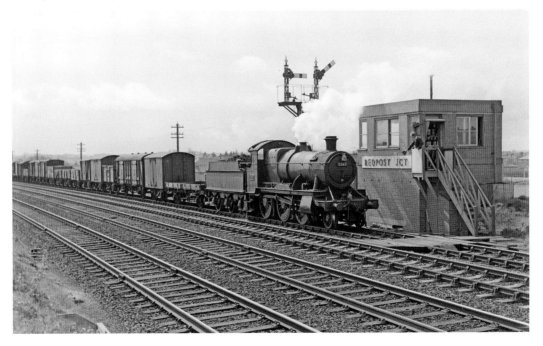

The 1873 Act required the M&SWJR to maintain a separate track from Red Post into Andover station. This restriction was relaxed during the First and Second World Wars and a physical connection was provided at Red Post. Ex-GWR 2-6-0 No. 5367 is seen in 1955, passing the SR wartime signal box of 1943. (Richard C. Riley/Transport Treasury)

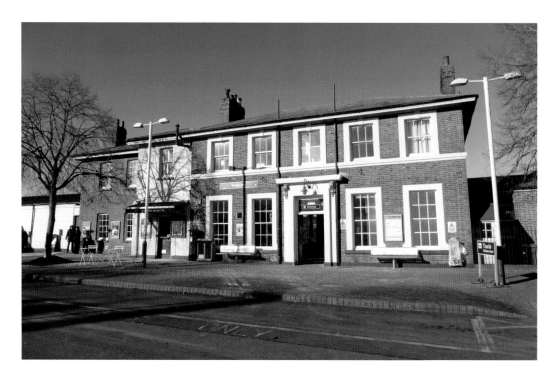

Andover station opened on 3 July 1854 with the first section of the Basingstoke & Salisbury Railway, which was completed to Salisbury on 1 May 1857. It remains open on the main line from London Waterloo to Exeter. (Author)

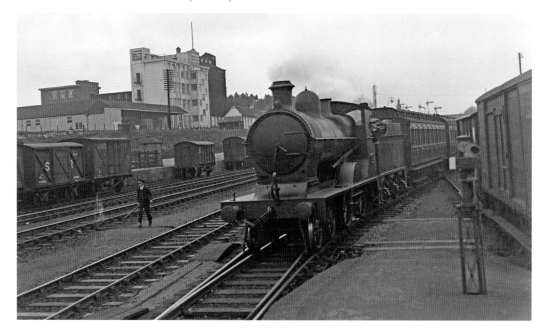

Ex-M&SWJR 4-4-0 tender locomotive No. 1122 (originally No. 4) is seen entering Andover Junction's main line island platform from the west in April 1934 with a southbound train. (Dr Ian C. Allen/Transport Treasury)

A view looking west from the island platform at Andover station in November 2017. M&SWJR trains were able to reach either of the two platform faces from the line from Red Post. The station was restored in 1986. (Author)

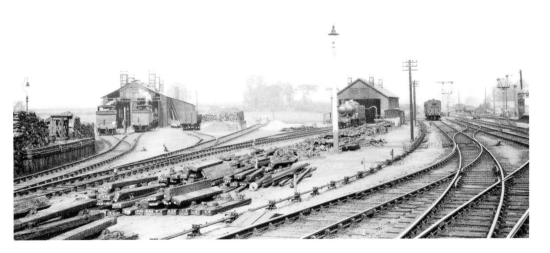

The M&SWJR locomotive shed at Andover was at the east end of the station and is seen here to the right of the former L&SWR engine shed in April 1928. A rebuilt M&SWJR 4-4-0 stands outside the GWR shed. Industrial units now occupy the site. (H. C. Casserley via Mike Barnsley)

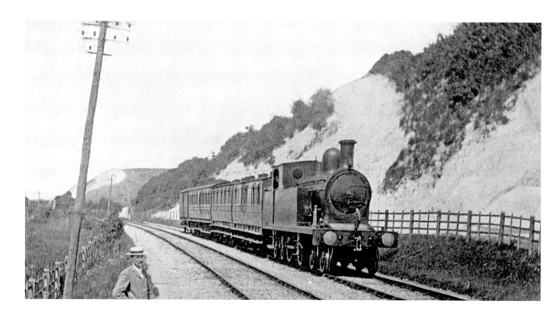

This image, taken from a postcard, shows M&SWJR 4-4-2T No. 18 hauling a short passenger train on L&SWR tracks near Stockbridge on the Andover & Redbridge line. The engines were well suited to the winding route. (STEAM Picture Library)

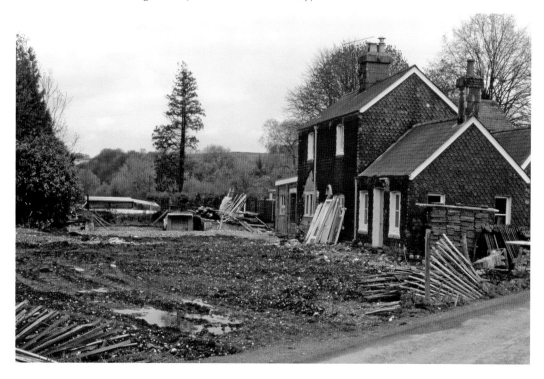

The remains of Mottisfont station, as seen in 1976. The station opened in 1865 on the Andover & Redbridge Railway, which formed a vital link between the M&SWJR and the South Coast. Passenger services were withdrawn in September 1964 and the line closed to goods three years later. (Peter Russell)

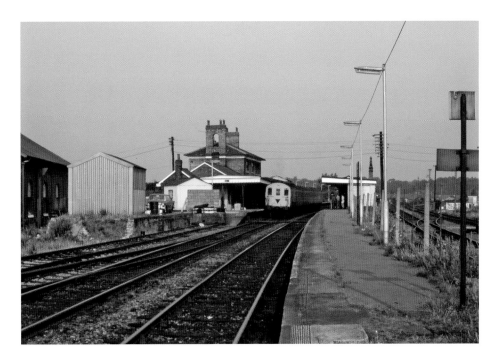

The Andover & Redbridge Railway joined the L&SWR line from Salisbury to Southampton at Romsey. The station remains open and is seen here on 18 August 1976 with a northbound Southern Region diesel electric multiple unit (DEMU). (Peter Russell)

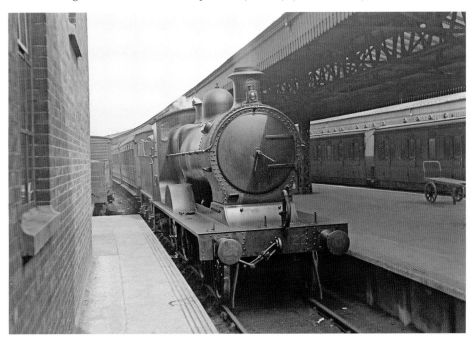

Ex-M&SWJR 4-4-0 tender locomotive No. 1122 is seen with a train from Cheltenham at Southampton Terminus in April 1934. Built by NBL in 1914 as M&SWJR No. 4, the engine survived until November 1935. (Dr Ian C. Allen/Transport Treasury)

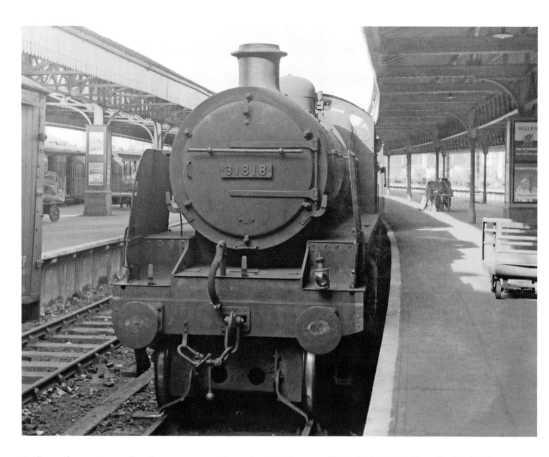

A through service to Southampton continued until closure of the M&SWJR line. Ex-SR N Class 2-6-0 No. 31818 stands at Southampton Terminus with the afternoon train from Cheltenham on 26 July 1961. (James Harrold/Transport Treasury)

Acknowledgements & Sources

I am very grateful to the following who read draft text at various stages and kindly commented on content and style: David Viner, Laura Dickinson, Mike Barnsley, Neil Lover, Roger Barber, and Tim Bryan. Mike Barnsley and David & Linda Viner also provided additional information and pointed me to other sources. David Viner and Laura Dickinson kindly facilitated and accompanied me on field trips.

The following also kindly provided access to, and granted permission to use, images of their own or from their collections, many of which there has sadly not been space for: Andrew Parry & Paul Evans (Gloucestershire Archives), Ben Brooksbank, Darryl Moody (Local Studies, Swindon Libraries), David Viner, Felicity Jones (STEAM Picture Library), Jennie Bridges & Robert Townsend (Swindon Society), Julie Davis (Wiltshire & Swindon History Centre), Katie Flanagan (Brunel University London Library), Margaret & Mary Casserley (Casserley Collection), Mike Barnsley, Neil Lover, Paul Chancellor (Colour-Rail.com), Peter Russell, Rebecca Sillence (Cheltenham Local & Family History Library), Robin Fell (Transport Treasury), Robin Webster, Roger Barber (Swindon & Cricklade Railway), Roger Carpenter (Lens of Sutton), Sarah Dutch (Historic Environment Scotland) and Sophie Cummings (Swindon Museum & Art Gallery).

Jon Dixon (Anglezarke Dixon Associates) produced the wonderful map at very short notice, and Stephen Laing (Curator, British Motor Industry Heritage Trust) helped to identify motor cars that appear in some of the photographs. Barrie Trinder was the traveller on the line in May 1961 when BR 4MT 2-6-0 locomotive No. 76068 required remedial attention to its sandbox at Cricklade. Thanks as ever to everyone at Amberley Publishing for their help and patience.

I have not consulted primary sources to any great extent for this book, though it was fascinating reading the original Bills for the SM&AR, S&CER, and M&SWJR. Rather, I have made extensive use of published resources, including the three excellent Wild Swan Publications *Midland & South Western Junction Railway* volumes by David Bartholomew (vol. 1, 1982) and Mike Barnsley (vol. 2, 1991, and vol. 3, 1995, covering locomotives, carriages and wagons). T. B. Sands' *The Midland and South Western Junction Railway* (1959, revised by S. C. Jenkins 1990) and Colin Maggs' book of the same title (1967) are good general histories, but there do seem to be some conflicting dates. David Barrett, Brian Bridgeman & Dennis Bird prepared two books: *A M.& S.W.J.R. Album: A Pictorial History of Swindon's 'Other' Railway, Vol. 1 1872-1899* (1981) and *Swindon's Other Railway: The Midland & South Western Junction Railway, 1900-1985* (1985).

Published in 2000, *Cheltenham to Andover including the Tidworth Branch* by Vic Mitchell & Keith Smith is in the usual Middleton Press format, while John Stretton's *The Swindon & Cricklade Railway and former Midland & South Western Junction Railway lines* (2003) covers the route from Andoversford to Marlborough in a 'then and now' style, with a section on the S&CR's preservation activities. An article on the M&SWJR by the inimitable E. L. Ahrons was published by the *Railway Magazine* in 1923 as part of

his *Locomotive & Train Working in the Latter Part of the Nineteenth Century* series, and was reprinted in 1953 by W. Heffer & Sons.

There is of course much information available via the internet, including Neil Lover's extensive *Swindon's Other Railway* website. I have tried to ensure that information in the book is correct, and not repeat past errors where I am aware of them, but of course take full responsibility for the end result and any remaining errors.

Every attempt has been made to seek permission for copyright material used in this book. However, if we have inadvertently used copyright material without permission or acknowledgement we apologise and we will make the necessary correction at the first opportunity.